D0472165

Drawing and Painting

ON THE

iPad

NO LONGER PROPERTY
OF ANYTHINK
RANGEVIEW LIBRARY
DISTRICT

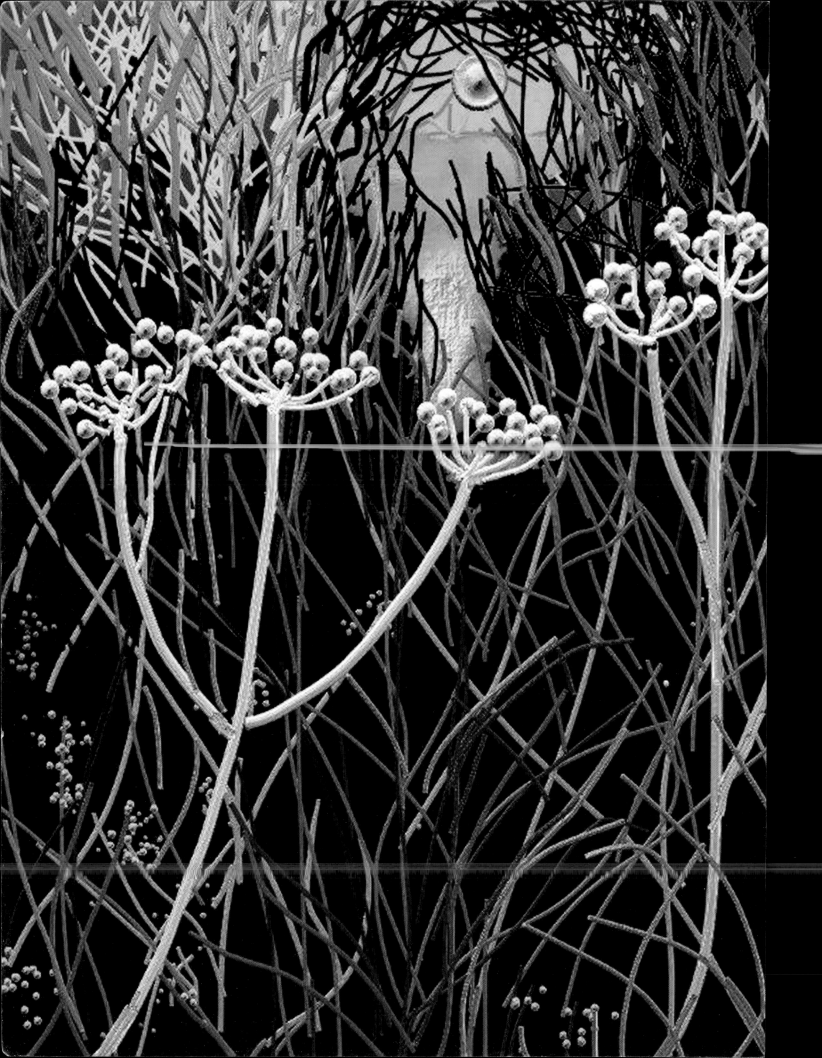

Drawing and Painting
ON THE
iPad

Diana Seidl

THE CROWOOD PRESS

First published in 2015 by
The Crowood Press Ltd
Ramsbury, Marlborough
Wiltshire SN8 2HR

www.crowood.com

© Diana Seidl 2015

All rights reserved. No part of this publication may be reproduced or transmitted in any form or by any means, electronic or mechanical, including photocopy, recording, or any information storage and retrieval system, without permission in writing from the publishers.

British Library Cataloguing-in-Publication Data
A catalogue record for this book is available from the British Library.

ISBN 978 1 78500 027 0

Acknowledgements

It is with support from others that this book has been produced. I believe this has been a very positive aspect, as it has illustrated so many different ways in which the iPad can be used. Janet Phillips has been a truly invaluable supporter from the beginning; her training with computers has kept me on the straight and narrow. Also I must thank my husband Tom Bedwell. We share an office and without his patience and constant attention, when the technical aspects of the computer proved too much for me, the book would not have got written. To David Whitehead thanks also, for his corrections to my artistic English.

Graphic design and layout by Peggy Issenman, Peggy & Co. Design
Printed and bound in Malaysia by Times Offset (M) Sdn Bhd

Contents

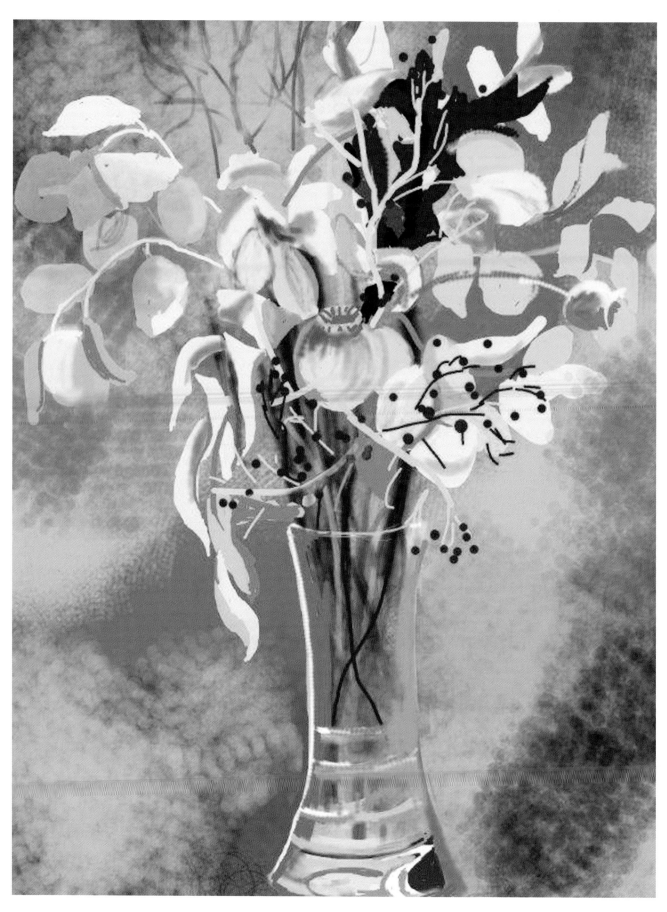

Seeds of Autumn by Janet Phillips. Janet completed this picture in her U3A Art Group. This dried flower arrangement was on the window sill and she drew it directly using Brushes XP. Three different layers were used, one for the flowers, one for the vase and one for the background. The textures used in the background are very typical of the Brushes XP app.

Preface

t is the very nature of technology that innovation is constant. As I have been writing this book the software on the iPad has been updated three times, with some significant changes. I have tried to think as far ahead as possible and even if the technology changes somewhat, the basic precepts of the book – about making a good picture on the iPad – are constant. The pictures remain to inspire you and encourage you towards creativity and innovation with your iPad work.

Your creativity may need to extend to being versatile with some of the settings mentioned, and looking for them somewhere else on the screen. The iPad is so flexible: you can experiment freely, as errors can easily be rectified.

Dedication

I have spent the most wonderfully happy life teaching Art. Teaching for me was always about sharing and about enthusing others to go on and be creative in a wide range of fields, feeling a sense of tangible satisfaction in what they produce. So it has been with this book.

Unlike many subjects, Art does not have any prescribed answers. You may need to be taught *how*, but then the rest of it is up to you and your creativity. I was not a child of the technical revolution and many aspects of technology remain quite difficult for me, as for so many others born in the 1940s, I suspect. When I started teaching myself about the iPad I felt each step was hard won; I hope this book might save you that slow process.

After buying the iPad I searched for courses or people who knew more than I did, but was bitterly disappointed. It was through sheer luck that I talked with a fellow member of my local Arts Guild and she said there was a U3A group of artists nearby who were ploughing a furrow by learning to draw on the iPad. This group has provided much of the inspiration and knowhow for this book, supplying many of the illustrations. We have learnt in a very real way from each other, discussing problems and setbacks and often asking, 'How did you do that?'

Once you get going, I recommend that if possible you find some like-minded folk so that you can help and encourage each other. We still meet once a month and just concentrate on one aspect of the technology and really try to conquer our difficulties. We always have homework to keep us practising through the month. I cannot stress enough the value of practice, practice, practice, just like the piano, till you get really confident about using and choosing the tools, so that their settings and presets become second nature to you.

To write this book has been a rewarding experience. My hope is that these words will encourage you to a creative life with the iPad. Good luck – it is a truly fulfilling journey!

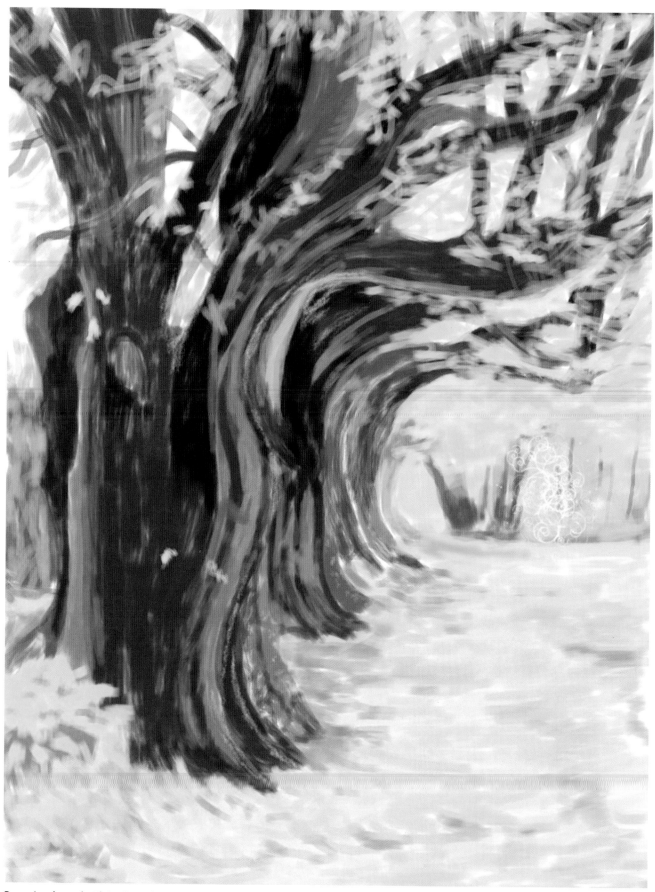

Devon Landscape by Elaine Fear. Elaine made this image from a photograph she had taken herself while on holiday in Devon. She used Brushes XP and started by drawing the outline of the trees on a white paper. Gradually the foreground trees were emphasized to make them come forward and the background trees were left to recede. An orange ground was placed underneath the trees and the fallen leaves drawn on top. Highlights were introduced to give the trees more form, then finally the foliage was added.

Introduction

> The iPad is a very serious medium. It's just a new one and it affects the way you do things.
>
> **DAVID HOCKNEY**

The first hint of digital art for most people came when they saw David Hockney's iPad prints at the Royal Academy Exhibition of Spring 2012. For those who were not graphically inclined or from a design background, these drawings came as a complete revelation. This was an exciting and very different way to draw. A truly vibrant exhibition, it showcased David Hockney as a highly versatile and creative artist with a vast range of oil paintings, watercolours and a completely new genre of digital art. Many landscape pictures from real life, which had been produced digitally and displayed in one room, made a stunning visual treat.

Hockney is to be greatly admired for his constant innovation. Not one to bask in already assured fame, he seeks new ways of portraying what he sees around him. He has an insatiable desire to use new technology to the full.

Hockney first started drawing on the iPhone but then wanted a larger screen. In the catalogue for the 2012 show, *A Bigger Exhibition*, he quotes people from his Yorkshire village. 'We hear you've started drawing on the telephone,' to which he replies, 'Well, no, it's just occasionally I speak on my sketchpad'.

The instant accessibility of the iPad was also very appealing to him: no messing about with water or sharpening pencils, just draw. He had special pockets made in his jackets so he could carry sketchbooks; these now often carry the iPad. He believes iPad art is influencing contemporary painting with its boldness and speed. Throughout time, artists have pushed the bounds of creativity but we must thank him for bringing digital art to a wider audience through that exhibition.

Another famous advocate of the iPad is Andrew Marr, rather surprisingly for many people as he best known as a broadcaster, political commentator and journalist. In his inspiring publication *A Short Book about Drawing* he catalogues his lifelong interest in drawing and painting and the importance of 'doing and making for a happy life.' His busy schedule travelling around the world to fulfil professional commitments has left little time for packing loads of art equipment, so what better drawing tool than the iPad to carry with him? It packs flat and is easily available at the drop of a hat, with no WiFi needed. The iPad drawings in his book were made with the Brushes 2 app, sadly no longer available. Now only Brushes XP is available, which is quite different. His very lively and perceptive drawings on the iPad illustrate that you should just draw wherever you are and whatever you see. Even more relevant to Andrew Marr, who suffered a stroke in 2012, was that he found that the iPad provided a haven of spiritual satisfaction immediately after the stroke. Even with the use of only one hand, it was still possible to draw on the iPad with the stylus. At a recent lecture he stated that starting to draw after the stroke helped establish who he was again.

The iPad provides a very welcome tool for those who are disabled, giving them the possibility to paint and draw sitting on the sofa. Even for those with only a mild disability, the paraphernalia of painting and drawing may get in the way of making art. Spilt water and paint on clothes, not to mention the clearing up at the end, are a huge turn-off. This clean, easy tool gives the artist the versatility of oil paint, watercolour and chalk – to name but a few of the ArtRage tools – without the mess. It all seems just too good to be true.

Recently I taught an iPad course for beginners. One of the students said, 'I knew I had this marvellous piece of technology but I really did not know how to use it.' The younger generation readily understand and accept the new technology, they have grown up with it, but there is a large group of people who would like to know more about it too. This light, portable, artistic tool needs to be explained if you want to make real progress. Of course you can teach yourself but it takes much longer. If the basics are explained you will make much quicker progress.

After my standard computer had broken and I had seen the David Hockney iPad prints, I decided to buy an iPad. This seemed to be a natural progression. Excited by this new tool, I was then deeply disappointed that there was no help to get started. A short course at the Apple store which showed me the basics of using the iPad was vaguely useful but there was no help with using it for artistic purposes. There were videos on the Internet which showed people doing absolutely wonderful things drawing on their iPad but it was all so competent and rather mind-blowing that it rather put you off. There was a surprising paucity of books on digital art and none that approached the subject from a fine art perspective. Most seemed to be graphically inclined and presupposed you knew far more than you did. They were off-putting rather than encouraging. Many encouraged drawing over imported images and I really could not find a book to help me.

So why choose an iPad at all? What use is it?

Coming to the iPad from a fine art background made me very aware of the principles when making iPad pictures. What has surprised me is how this standard tool interprets the absolute character of the artist. The way you will use the iPad is the way you paint and draw with any standard tools and reflects your interests and artistic values.

The iPad will never fully replace real painting but it is an excellent adjunct for any artist. It gives a confidence with drawing and painting that is truly refreshing. New ideas can be tried and discarded at the touch of a button without the anguish of ruined paper or wasted materials. It is all a very liberating experience that transfers itself in a positive way when you go back to real paint and paper. There is an added confidence in the way you work. It is quite hard when one has been painting and drawing for a long time to find something that pushes you on into new fields of creativity but I believe the iPad is that something.

I hope after reading this book you will feel, as David Hockney did, that this tool is the future. He was over 70 when he said in 2012:

> *At first you think it is a bit of a novelty; it took me a while to realize it is quite a serious tool you can use and it took me a while to get skilful on it. Skill is practice. It is not just a novelty, I realize it is a quite new tool you can use.*

The aim of this book is to build knowledge and confidence with the iPad through some carefully planned exercises so that you can use it in a creative and meaningful way. I want to show you how it can become that tool you would not be without.

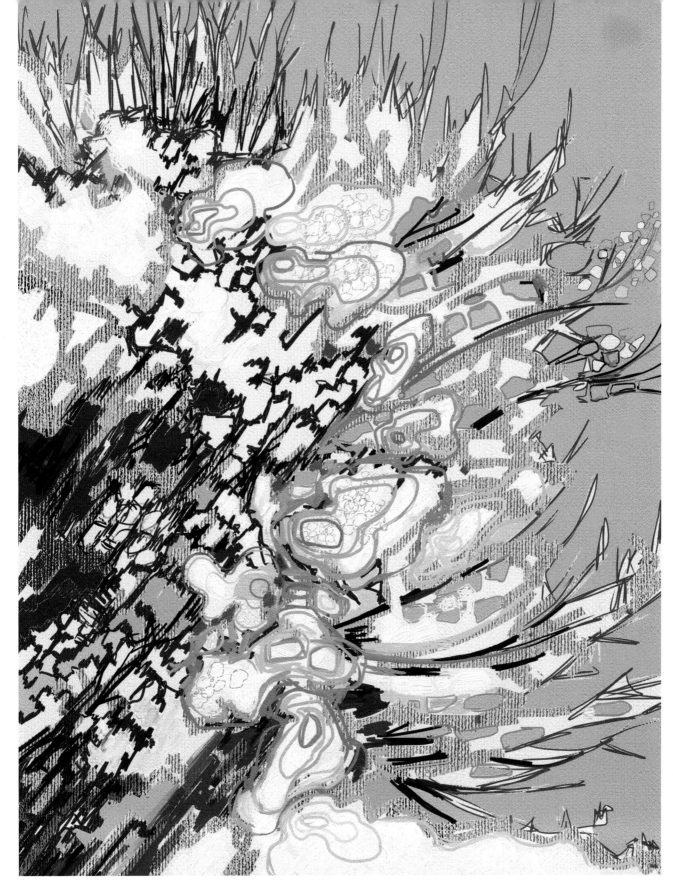

May Is Out by Judith Fletcher. Judith writes about making this picture: 'Inspired by a blackthorn hedge bursting into flower, I took photos and used them as reference to develop an abstract design. Using ArtRage I drew the underlying composition with Roller (Speckled Line) on Basic Canvas to make textured shapes. Lines were added with Round Oil Brush, Thick and Smooth Roller, and Eraser. Bucket Fill provided areas of flat colour. Other coloured areas were worked up with Rollers, Watercolour Brush (Wet on Wet), Oil Brush (Round, Square and Thick Gloss), with some details added with the Inking Pen. Layers were used throughout to try things out and then discard or merge into the image.

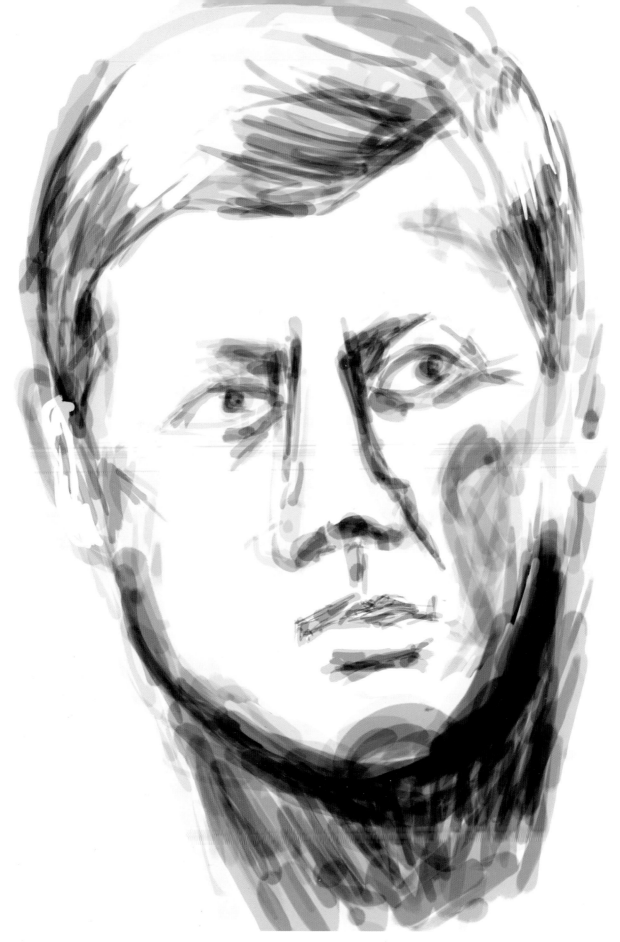

Fig. 1.0 This picture was freely copied from a newspaper. I have enjoyed drawing heads and doing portraits in art classes, and I felt that the Zen Brush, with all its wonderful tones, was completely applicable for doing a portrait. The outline of the head was sketched in with the very lightest tone of brush; always remember that you can erase any marks you feel are wrong. Gradually I moved to a slightly stronger tone brush, frequently altering the size as I progressed. With the Zen Brush app, the screen cannot be enlarged, so all the fine detail had to be put in with a very small brush. Working with very limited tones made one very disciplined.

Getting started with the

I am interested in all kinds of pictures, however they are made, with cameras, with paintbrushes, with computers, with anything.

DAVID HOCKNEY

We are now ready to begin on an exciting journey.

Many books about iPad art describe a vast range of equipment that is on offer for painting and drawing. But all you really need to begin is an iPad, a charger and a simple stylus.

Buying an iPad

When buying an iPad there are various factors to take into account. The latest version of iPad is the iPad Air 2 and this is lighter than the standard version, a great advantage when carrying it around. There is also the iPad mini but the screen is rather small for drawing on. If you buy the standard iPad you will be offered 16GB, 64GB, or 128GB. ('GB' stands for gigabyte and is a measure of the storage capacity of the iPad.)

If you envisage using it for storing lots of photos, videos, music, etc., you will need a high GB rating, which is more expensive. Although there are various deals online for buying a new iPad, I have felt most comfortable when buying this expensive piece of equipment from a local store. If anything goes wrong or you need some advice, it is then simple to take it back.

When first buying an iPad you will be required to create an Apple ID, if you have not already got one. When you create an Apple ID you will be required to link this ID to a payment source, which enables you to purchase a wide variety of things through the iPad. Although for art work we will only be buying art apps, it is possible to buy music, videos, etc., through the iPad. When you make any purchase you will be asked to type in your password for security reasons. Make sure that you have made a note of this. There will always be notification through email confirming your transaction.

Do take care if you buy a secondhand iPad as there are numerous cases online of people who have been unable to introduce their own personal passwords into used equipment. Also, older versions of the iPad run more slowly than the brand new ones. This is an important fact to bear in mind when using a memory-hungry app like ArtRage. Newer versions of the iPad also have a higher quality retina display, which means that images on the screen appear sharper with more pixels to the inch.

Choosing a stylus

Drawing with a stylus is, I believe, the best way to draw on the iPad though; many will advocate just drawing with a finger. However, fingers are often clumsy when you are trying to alter the settings. A finger does not always give the definition looked for when drawing. The finger also puts grease on the screen, which interferes with the conductivity.

At the moment there is a bewildering choice of styluses on the market. As you are a beginner, you will have no experience to bring to bear on your choice so I recommend buying a very simple stylus, one with a black, soft tip, from any high street retailer or online. It should not cost more than £10. This stylus will satisfy all your needs for the initial period until you get more fully conversant with the iPad and all its drawing and painting methods. As you progress, you can look at more sophisticated and expensive versions online and find one that really suits your personal needs.

When buying a new iPad it will come with a charger. And it is a good habit to charge the iPad regularly overnight. There is nothing more irritating than to have it run out of power just when you are in the middle of a major piece of work. (One student recently complained that her iPad would not work and she would have to take it back to the shop to get it fixed; it simply needed charging.)

Take care of your sensitive screen: do not use any scratchy point on it and keep it away from wet surfaces. Also do not leave it in bright sunlight for any length of time as this will render the iPad temporarily useless and it will take some time to recover. Try to keep your screen as clean as possible, using only a slightly damp, lint-free cloth. Do not use any strong cleaners. Having just paid a lot of money to buy the iPad you should treat it with care. The dealer will probably recommend buying a protective case; this is a worthwhile purchase.

So, having bought your iPad and stylus, you are ready to go.

Downloading an app

Opening the iPad there is a start/wake button on the left; press here to turn the iPad on. This is also where you press to change to a different app, for example if you wanted to change from ArtRage to Brushes XP. After that it will be necessary to tap in a personal number that will give access to the iPad. This is your passcode, which you set yourself from the settings icon on the initial screen. The dealer who sells the iPad should help with this. On the right of the screen is a small black dot – this is the camera lens that faces outwards; on the back there is another lens for pictures going the other way. Make sure your hand is not obscuring the lens when you are trying to take a photo.

There are a number of icons on the start-up screen. Don't be dismayed – to get started with your painting and drawing it is not necessary to know about every icon, only the ones that are relevant to you. However, to paint and draw on the iPad you will need an app. ('App', a shortened term for 'application', in this instance refers to a piece of software that enables you to draw and paint.)

There are many different art apps on the market and it is really quite daunting to trail through them all. Zen Brush app was chosen for the first exercises described in this book as it is basic and simple to use; ArtRage was then chosen for the later, more complex exercises.

Now you need to put the app Zen Brush into your iPad (this is called downloading).

Tap on the apps store icon already on the main screen. On the next screen in the top right-hand corner there is the Search box; when you tap this a keyboard will appear from the bottom of the screen. Type in Zen Brush in the Search box, and tap the Search button on the keyboard. On the next page you will see Zen Brush displayed and probably other apps as well. At the present time we are only interested in Zen Brush. There is a small box that tells how much it costs to purchase. Select this and then there is the option to buy.

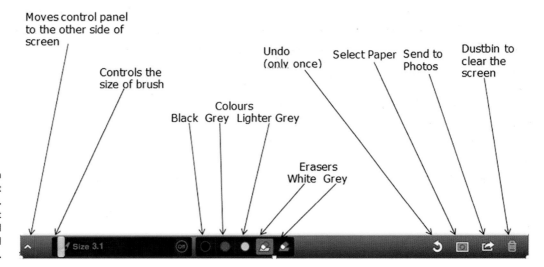

Moves control panel to the other side of screen

Controls the size of brush

Undo (only once) Select Paper Send to Photos Dustbin to clear the screen

Colours
Black Grey Lighter Grey

Erasers
White Grey

Fig. 1.1 Zen Brush screen. It is simple, but very artistic and intuitive. The screen gives you just eleven buttons to control and these are basic and straightforward.

Size 3.1

(Some apps are totally free.) Select Buy, then you will be required to enter the password for your account to authorize the purchase. After doing this, the app will go directly into your iPad and is ready to use.

Starting a new skill can be quite daunting and the first few experiences can put you off for life. The intention here is to start off in a very simple way. Using Zen Brush will give a wonderfully easy introduction to drawing with a stylus. This app uses a simulated ink brush with graduated tones, and just black and grey. The idea for artists to draw in this way, on a screen with a piece of plastic, is quite foreign to most people, but very modern – no dipping in water with a brush or sharpening of pencils. When I first started with the iPad I thought that the size of the mark was controlled by the stylus that I was using and that I would need a point to make a thin line. I quickly became aware that it was nothing to do with the stylus but was controlled by the settings on the iPad itself.

The nature of this app is implied by its title, Zen Brush; it is an ink brush app influenced by traditional Japanese painting and drawing styles. It is also quite magical to use for simple drawing in the western style. Tapping on the icon on your main screen will open up Zen Brush and the image (Fig. 1.1) shows what will appear.

Explanation of the Zen Brush Screen

At the far left there is a small arrow that moves the control panel to the other side of the screen. Tap on it and see what it does.

Next is a sliding panel that indicates the Brush size. Just slide this along to change the Brush size; the numbers indicate the

actual size of the Brush.

The next buttons are three circles, black, grey and white, which indicate the tones that are available to you.

The next two small buttons indicate the Eraser function: the first is a strong Eraser; the second results in a lighter tone rather than complete removal.

The curly arrow indicates the Undo and Redo buttons; these apply to the last brush stroke made.

The next small icon gives us a rather bewildering set of papers to choose from, with titles like 'Grunge' and 'Seasons'; scroll to see the whole selection. Some provide you with a really exciting surface to work on; some even have little pictures in the corner – explore them freely. Just tap on your choice and it will appear on the screen.

The little arrow within the rectangle is the next icon. It will give a number of options, which are largely self-explanatory. Save as Photo, the top heading, allows you to keep a piece of work that you are particularly proud of. It will be saved automatically into Photos on your iPad. This is a separate icon on the main screen of the iPad. You need to select the main on/off button to access Photos.

Select the dustbin icon when you want to clear your screen and start again.

In teaching classical drawing, students were encouraged initially to draw in black and white; not only is this simple app a good way to begin, it is also an excellent way to start learning about tone in pictures.

Fig. 1.2 Free marks with different sizes of brush.

Fig. 1.3 Marks using different tones.

EXERCISE 1
Hand-eye co-ordination

This first exercise is just about hand eye coordination – nothing too demanding at this stage. Moving a piece of plastic over a screen to make a mark is quite a new experience. Feel free and intuitive in this first exercise.

Select the Choose Paper icon, and select Plain White paper, then tap on the white screen to make the table disappear. Select Tone Black and Size 7 or 8 Brush and make some marks over the surface. Change the size as you work. Feel the stylus slipping over the screen as you draw and make marks. If you do not like what you have done, select the dustbin icon and start again. Try to make a harmonious pattern over the screen by looking at the relationship of the white paper to the black marks. The Japanese were very keen on the relationship of the positive to the negative and the influence of Japanese prints on European Art in the late nineteenth century was very strong indeed. If you are happy with your picture, select Save to Photos.

Note: the speed of the brushstroke will affect the thickness of the line. For example, if you speed up at the end of a line it will have a tapered end just like a real brush.

EXERCISE 2
Explore the Zen Brush

Feeling more confident with mark making, fully exploit the different tones that Zen Brush offers. Enjoy using all the shades, in a purely abstract way. Do not try to draw anything figurative at this stage.

To begin again select the dustbin button and this time select Japanese Paper 1. Choose a larger Brush size. Make marks of different sizes over one another, remembering to think about composition on the screen. Use different tones. When you have made several marks, select the Eraser and make some artistic rubbings out, using the Eraser in large sweeps. Once you have made your erased marks, it is also possible to continue with some more drawing into your picture. Save it, if you are pleased with it.

Fig. 1.4 Painting a flower with Zen Brush.

EXERCISE 3
Painting a flower

By now you should feel happier with what you can do with this app. Try to paint a real or imaginary flower overlaying the tones to make subtle changes.

The Zen Brush behaves much like a watercolour brush and when starting with the mid-tone it is possible to gradually build up the tonal structure. For this exercise choose White Paper. Now try to paint an imaginary flower, selecting a fairly small Brush (about Size 8). Paint it fairly large so that it is easy to represent the changing tones. The wonderful thing is that the tones overlay one another and become darker, just like real watercolour. Draw freely and remember you can erase a stroke at the touch of a button.

EXERCISE 4
Experiment with paper

Experiment with the different kinds of paper offered by this app. Choose White Paper and draw an imaginary bowl of fruit quite large so that it fills your page. Vary the size of the stroke and tone as you work. When you are happy with what you've done, go into Paper Selection and choose a light coloured paper, such as orange. Tap on this and your whole picture will turn orange and your drawing will show through nicely.

You should also experiment with Grunge, Lantern and Moon, all exciting paper choices.

Do lots of practice here, till there is a feeling of confidence with the stylus and moving the sliders about to change the size of the brushes.

Now that you have mastered the first stage of drawing on the iPad, you are ready to go on to the next challenge.

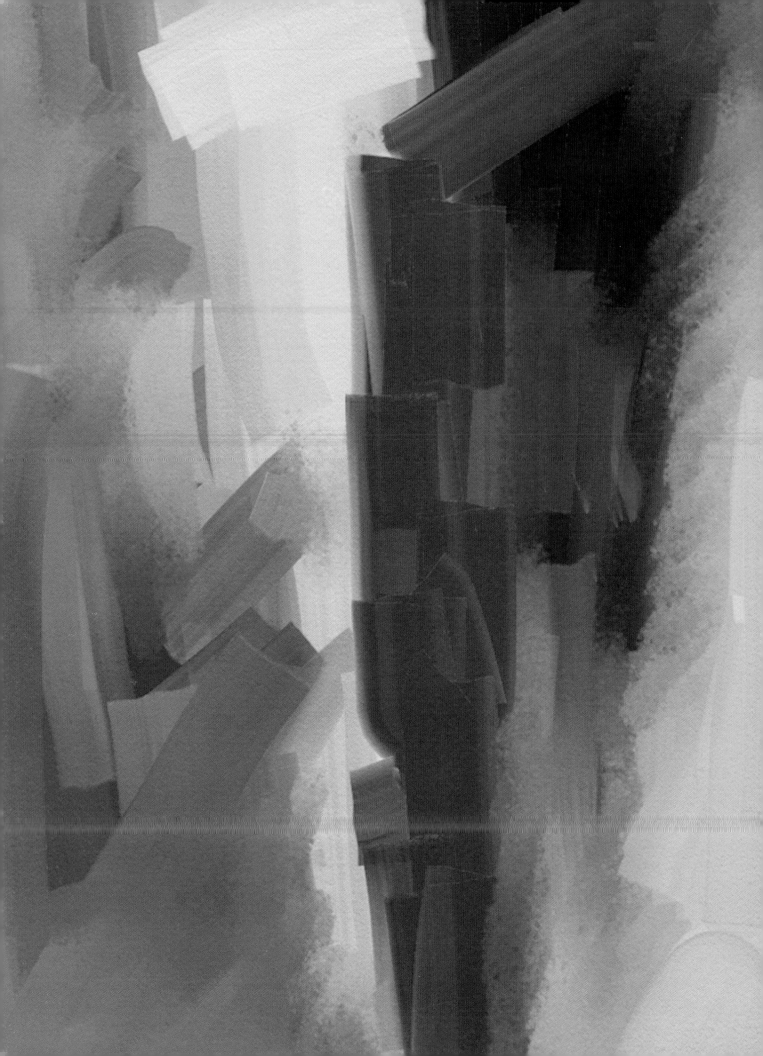

Introduction to

ArtRage

en Brush is an excellent way to get started, with its simple screen and no colour; now we can progress and get to know another app that gives a greater range of possibilities to work with.

Download ArtRage following the instructions for downloading from the app store in Chapter 1.

Fig. 2.0 This picture was very much about enjoying paint going down on the surface and being conscious of the arrangement of lights and darks over the picture plane. There was no figurative intention in this image. It was made with the Oil Brush in ArtRage on a fairly large size with some blurring with the Palette knife. The centre of focus was made by positioning the strong light with a strong dark in the central area of the picture.

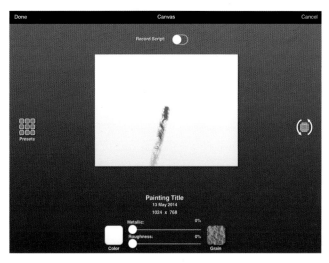

Fig. 2.1 Now tap on the ArtRage icon on the main display and the page will soon appear. Tap again and you will be faced with a screen like this.

Fig. 2.2 Screen for choosing paper.

Screen for choosing paper

This first screen is basically for choosing what kind of paper surface to work on. One of the great advantages of ArtRage is that there are many different types of paper and it is possible to select one that will suit the kind of tool that you choose to use, for example, watercolour paper to fit a watercolour brush.

Select the Canvas Presets icon with the stylus and there will be a choice of many different kinds of paper surface. Ignore the other icons at present. The blue marks on each piece of

paper are an indication of how colour reacts when placed on this surface and how the grain of the paper shows through. The illustration below shows some of the papers available; scroll down to see the full selection of papers.

Having decided which paper to work on, simply tap on it and the screen will change again. Now there will be a screen with the selected paper in the middle. (There are other items at the bottom of the screen but a description of their function will discussed later.) Just tap Done in the top left-hand corner to confirm your choice of paper and the screen shown below will appear.

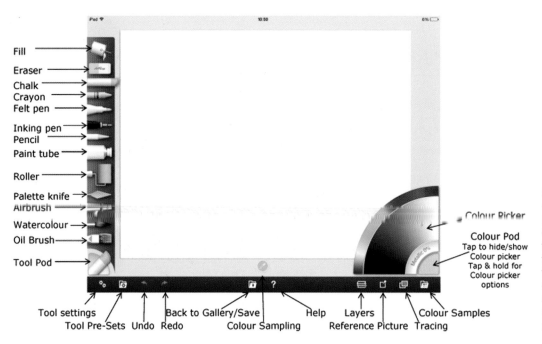

Fill
Eraser
Chalk
Crayon
Felt pen
Inking pen
Pencil
Paint tube
Roller
Palette knife
Airbrush
Watercolour
Oil Brush
Tool Pod

Colour Picker

Colour Pod
Tap to hide/show
Colour picker
Tap & hold for
Colour picker
options

Tool settings
Tool Pre-Sets Undo Redo
Back to Gallery/Save
Colour Sampling
Help
Layers
Reference Picture Tracing
Colour Samples

Fig. 2.3 Main screen display. The screen now shows a selection of thirteen tools down the left-hand edge and the Colour Picker on the bottom right-hand corner. There are also some useful tools on the bottom bar below the main screen.

Main screen display

Beginning a new skill can be quite daunting and it is crucial in the initial stages not to be overwhelmed with information. Not everything will be explained from the start but you will be given enough detail to get you drawing and painting as soon as possible.

Firstly, these are various tools that are available in the ArtRage app.

Two small arrows on the left-hand side of the screen make it possible to undo and redo the drawing or painting marks you have made. Continually tapping the Undo button will take the image back further and further.

Tool selection

On the left there are images of thirteen different tools and these are clearly identified in Fig. 2.3. Select one by tapping on the tool with the stylus. The Tool Pod in the bottom left-hand corner then indicates the tool chosen. Practise changing the tools and see how easy it is.

Colour selection

A colour is selected by using the Colour Picker. To start with, put the stylus on the colour pod and hold it there for several seconds. A chart will then appear showing many different options. Select LS/H Picker (there are other options, but they can be ignored for now). Select this with the stylus and then tap the empty section of the screen to make it disappear. There are now some quarter circles; the outer ring section shows the range of basic colour. There is a small circle in this thin outer ring and by putting the stylus on this small circle you can practice moving through all the primary colours. The Colour Pod, in the bottom right corner, will give you a clear indication of the colour. Moving in from the outer ring, the wider quarter circle represents the tonal value of the chosen colour. Again there is a small circle and by placing the stylus on this and dragging it wherever you wish within that section, it is possible to alter the tone of the colour. Alternatively just tap on the screen with the stylus within the tonal area. The next quarter circle is the metallic function. Put the stylus on here and see how the colour becomes shiny.

Now practise moving the small circle in the outer ring and the small circle in the next ring to change the colours and tonal values. Note how the colour changes in the Colour Pod, reflecting the choice. Sometimes the small circle is difficult to move, in which case try tapping on the area to change the colour rather than sliding with the stylus. Changing something can often be done by tapping on the screen.

When using a range of different colours in a picture it is sometimes desirable to go back and use one particular colour again. To do this tap on the Colour Sampling Tool, shown as a paint dropper in a grey ring; it is between the Back to Gallery and the question mark at the bottom of the screen. Tap on the colour sampling tool and then tap with the stylus on the colour you wish to replicate. Your chosen colour will then appear automatically in your colour wheel, for you to draw and paint with. It will also appear in the Colour Pod. This is particularly useful when you are not quite sure how you arrived at that colour in the first place.

First marks with ArtRage

GETTING STARTED WITH THE OIL BRUSH

First select the paper, Canvas Basic. Tap on this, then Done in the top left of the screen. Now pinch in to bring the paper to the centre of the screen: to do this place a thumb and finger widely spaced apart on the screen surface and pull them together and the paper surface will become smaller, enabling

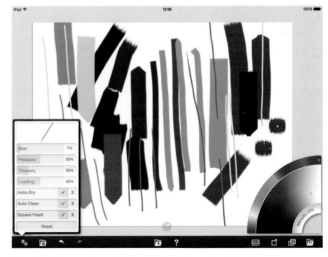

Fig. 2.4 First marks with the Oil Brush. Practise this a few times to gain confidence using the stylus. Make decisive changes with the colour selection and the size of the Oil Brush and see how a lighter tone will overlay a darker colour.

you to draw to the edges of the paper. For choice of Tool tap on the Oil Brush icon which is almost at the bottom of the Toolbar. The brush will move forward on to the main screen and will then be shown in the Tool Pod on the bottom of the Toolbar.

Now select the Tool Settings icon, represented by two small cog wheels, which is in the bottom left-hand corner of the screen below the Tool Pod. This icon represents the choice of settings for the Brush, e.g. Size, Pressure, Loading. The settings allow definition of exactly how the chosen tool should be. It may be a few seconds until the table with the settings appears; then there are seven different settings for the Brush. At this point we will not be too fussy about what to select; the idea is to make some marks and feel how exciting it is to paint with the iPad. To select your settings for the Brushes, place your stylus on the different headings of Size, Pressure, Thinners and Loading. To begin with, choose Size 50%, Pressure 50%, Thinners 10%, Loading 50%. Insta-Dry Auto Clean and Square Head options should also be ticked and green. Change the settings, trying to make different kinds of marks. It may take a few seconds for the changes to take effect; ArtRage uses a lot of memory and can be a little slow.

Next select a colour and tone from the Colour Picker and start to make some marks, exploiting the change of tone and size of brush.

Once the surface is fully painted a new piece of paper will be needed. In the middle of the icons at the bottom of the screen, there is one that looks like a small open book with an arrow on it. Select this with the stylus and three different options will be visible: Save, Save a Copy, and Back to Gallery. Use the stylus to select Back to Gallery. Now there are three further options: Save, Don't Save, and Cancel. Select Save. This will automatically save your picture into the Gallery. All the pictures saved are stored here and information will be given later on how to name them.

Practising with the Oil Brush

Still using the Oil Brush, choose a different kind of paper (don't forget to pinch it in). Try to fill the paper with different sizes of marks and different colours. Try to grade the colours dark to light from left to right. Remember if there is a mark you do not like, simply tap the Undo button.

To use the largest area of the paper possible, get rid of all the tool icons and the Colour Picker so it is possible to draw on the whole screen. Just tap on the Tool Pod and the Colour Pod to make them disappear and the edges of the paper will be clearly visible. If you are happy with what you have done, select Gallery in the middle at the bottom of the screen, then select Back to Gallery. After that, select Save and your picture will automatically be saved into Gallery. Now you are ready to start a new picture. You could continue with some further practice with the Oil Brush or go on to the next exercise.

Fig. 2.5 The screen shows experiments with mark-making and colour-changing.

ORDER OF WORKING FOR ALL PICTURES

1 Ensure you are in Gallery.
2 Select New Painting (top left of the screen).
3 Select the paper by tapping on Presets. Tap on chosen paper.
4 Select Done (top left-hand corner).
5 Pinch in. Start to paint!

Making marks with the Pencil

The first exercise was with a brush, making some painterly strokes on the screen; the next is a completely different exercise with a pencil.

This is the seventh tool from the top of the Toolbar. Select this with the stylus and it will move forward and appear in the bottom pod. Now select Settings (the double cog wheel icon on the far left at the bottom of the Toolbar). After you have selected this you may need to wait a few seconds for it to appear. A set of default settings will appear; all tools have a group of settings that are unique to that particular tool. The default settings of the Pencil are Size, Pressure, Softness, Tilt Angle, and Precise. You do not need to change anything to be able to draw immediately. Now set your colour with the Colour Picker. It is a good idea to start with a dark colour and experiment with different settings of Size, Pressure, Softness, and Precise/not Precise. You can change the settings by putting the stylus on the chart and sliding it freely over the headings. Now experiment with lots of different sizes of Pencil Pressure and Softness. Try to use the stylus like a real pencil, and experience a real freedom of expression as you make the pencil do what you want it to do.

When I first started with the iPad, I thought I could write down all the settings to help me remember them, but it simply did not work. The impact of the various settings needs to be carried as far as possible in the memory. This will gradually, after lots of practice, become instinctive.

If you are happy with any of your pencil pictures you can save them into the Gallery. It is always useful to look back and see how you have progressed.

A simple portrait in pencil

Choose a fairly large picture to copy, with clear features. Select Basic White paper to draw on and, using only the default settings (you could use others if you feel confident) and with black only, quite simply copy the image from the paper, using shading if you wish.

When you are happy with the result, select Back to Gallery. When the screen changes, select Save and your picture will be saved into the Gallery.

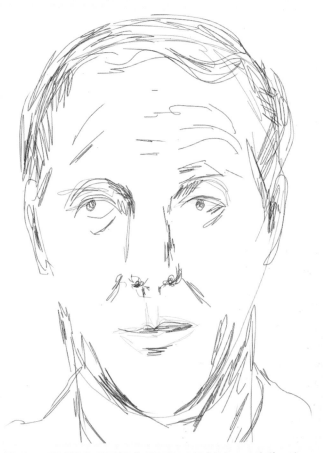

Fig. 2.6 This is an example of a simple portrait in in pencil. Choosing a new piece of paper but staying with a Pencil Tool, find a black and white portrait picture to copy from the newspaper.

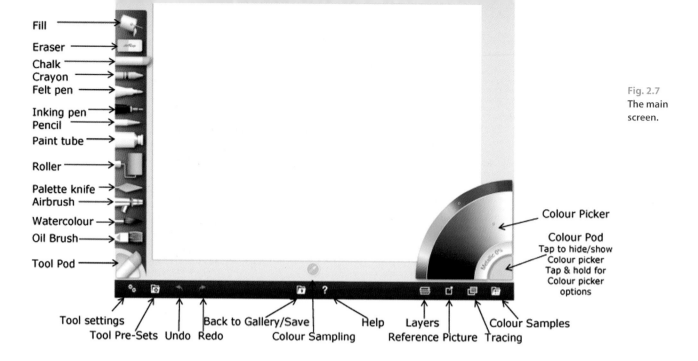

Fill
Eraser
Chalk
Crayon
Felt pen
Inking pen
Pencil
Paint tube
Roller
Palette knife
Airbrush
Watercolour
Oil Brush
Tool Pod

Colour Picker
Colour Pod
Tap to hide/show
Colour picker
Tap & hold for
Colour picker
options

Tool settings
Tool Pre-Sets Undo Redo
Back to Gallery/Save
Colour Sampling
Help
Layers
Reference Picture
Colour Samples
Tracing

Fig. 2.7
The main
screen.

Explanation of the icons on the ArtRage screen

Although good progress can be made without knowing in detail about all the icons, some knowledge of them will add to your creativity as your skills improve.

At the very top of the screen, on the left, is a little curved symbol next to the word iPad which appears when the iPad is connected to the Internet. In the middle of the screen is the time, and in the top right corner is a symbol that shows you how much power you have left. Do check this regularly and charge your iPad overnight when necessary.

The tools down the left-hand side are almost all self-explanatory but they are labelled on the diagram above for convenience. The question mark at the very bottom of the screen represents the Help section of the app (see below). Within this Help section there is a Tools section and this details very clearly what each tool does.

Along the very bottom of the screen you will see:

TOOL SETTINGS

This icon, represented by two small cog wheels, gives a basic selection of options for the chosen tool (Size, Pressure, etc.). The various tools have different settings, so for example those for Chalk Tool are different from those for Watercolour. All tools have a set of default settings.

TOOL PRESETS

This icon provides a further refinement of Settings. With Presets you can actually choose how the paint is applied to the surface of the paper. For example Dry Brush/Lots of Water, etc. The choice of Presets gives a shortcut to exactly the kind of marks you need without going into Settings. For example, if you were using the Oil Brush and you wanted the oil paint to go onto the surface like Thick Gloss you could simply select this Preset and the Oil Brush would automatically make those kinds of marks. Tool Presets also allows you to save your favourite settings.

REDO AND UNDO ARROWS

These are two of the most useful icons on the screen. They enable you to undo and if necessary redo all the marks that you have made. So if you do something you don't like, tap your stylus on Undo and the marks will disappear. If you change your mind and want that mark after all, simply tap on Redo.

BACK TO GALLERY

Selecting this icon is a way of clearing the screen to make way for a new picture. It is also the Gallery where you can label and store your work; here you can view your pictures by scrolling from left to right.

HELP (REPRESENTED BY A QUESTION MARK)

This icon is handy for helping explain some of the basic functions of the iPad. Within this icon there are many technical hints that will help in becoming more skilled in your use of the iPad. In addition to descriptions of the basic functions, there is information on memory and speed, as well as a useful forum where you can see other work done in ArtRage.

LAYERS

This icon allows you to superimpose one image on top of another. For example, the initial drawing, the background and the main focus can all be done on separate layers and then merged together to make a complete picture. Layers are explored in detail in Chapter 9.

REFERENCE ICON

This icon enables you to use an image from an outside source to make a picture.

TRACING

This icon allows you to import an image, reduce its opacity and then trace over the top to form your own picture.

COLOUR SAMPLES

With this icon you can store colours that you have enjoyed using and would like to use again at a later date. If for example you have just used a shade of green, a shade that you especially liked, select this icon. The term Add Sample will appear; select this to save the colour indefinitely, or until you choose to edit it. When you want to use the colour again, simply put your stylus on the chosen colour in your Colour Samples and it will be there at the end of your stylus.

This chapter has focused on controlling colour, using the Pencil and Oil Brush, and saving and naming your work in ArtRage. In the next chapter, these and other features of this app will be explored in more detail.

SAVING AND NAMING YOUR PICTURES

If you wish to name your picture, select Back to Gallery and then Save. The picture saved into the gallery will be clearly visible but underneath it there will be the words 'Painting Title', usually followed by a number. Select Painting Title and a keyboard will appear at the bottom of the screen. There is then a rectangular sign showing Painting Title with a small cross at the end of the word. Select this and Painting Title will disappear, leaving it possible to use the keyboard and type in the name of your picture. Remember to start the name with a capital letter. After typing in the title, select Done. The picture will then be saved with others, in alphabetical order in the Gallery.

Fig. 2.8 **Aster by Angela Whitehead. This was drawn from an actual flower. Using only coloured pencil, Angela has portrayed the flower with great delicacy and skill. The settings scale shows how very small the size of the pencil actually was at some stages of the drawing.**

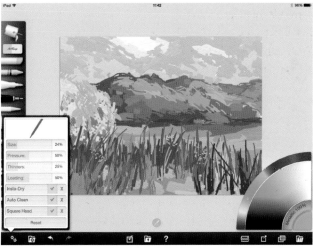

Fig. 2.9 **This landscape was based on a sketch done near where I live one summer. The whole picture was completed just by changing the size of the brush, using the settings shown.**

Fig. 3.0 This image was made by experimenting with the Inking Pen. This tool has many exciting options that need to be tried out. Choosing very limited colours, I experimented with all the different possibilities that were on offer. Taper length Smoothing and Square head Settings all played an important part in making the picture. There is deliberately no tonal variation in the picture and the very minimal recession is only achieved by size. As the marks were put down I was very conscious of their relationship to each other and the white spaces left by the paper; the Eraser was used frequently. The image works quite well the other way round, a good test of a balanced composition.

ArtRage
in depth : tools and processes

> The mind is the limit. As long as the mind can envision
> the fact that you can do something, you can do it,
> as long as you believe 100%.
>
> **DAVID HOCKNEY**

rtRage was chosen as the app we are going to examine in some detail because of the immense range of possibilities it gives to the artist. This single app gives the artist a most wonderful toolbox.

In Chapter 2 we looked at the initial screen in order to select the paper. The initial screen was not fully explained at that point, but now before we start examining the ArtRage tools another look at the first screen in a little more detail will be beneficial.

Looking at the illustration of the first screen on the following page (Fig. 3.1) you will see that underneath the choice of paper there is Painting Title (described in Chapter 1). Under that there is the date and beneath that there are two numbers: 1024×768 if the paper is landscape format. This is the default setting for your paper size. When you tap on the numbers it says painting width and height. One might think that these figures indicate the painting width and height in centimetres or millimetres, but in fact they represent the number of pixels in the picture – based on 72 pixels per inch. Pixels are the tiny coloured dots that make up the picture. Initially it is easiest to leave it like this; only change it if you want the paper to be a different shape. To do this tap on the numbers and the screen will change. There is a numbers chart at the bottom and in the centre of the screen a small table that will enable you to type in some new dimensions. Tap on the small cross at the end of the first dimension and select a new size. Note there is a maximum size of 2048×2048. After doing that, tap on the cross at the end of the second number and type in the new one. Then select the tick at the very end when you are satisfied that it is the right shape for you. Whatever shape you have, it will remain at 72 pixels per square inch.

Fig. 3.1 The first screen with full explanation of all the icons listed below.

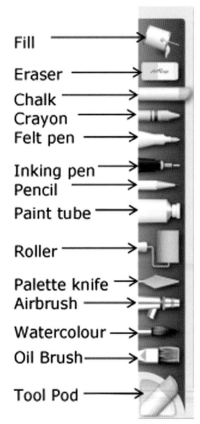

Fig. 3.2 The tools are described here in detail for you to decide which ones you like the best according to how you paint or draw.

At the start it is probably easiest to just leave your paper white to work on, but this screen gives you the possibility to change the surface before you start to draw on it. There are two circles with sliders, below Painting Title. These can change the paper to metallic and change the roughness of the paper; put the stylus on the sliders now and move them and see how the paper surface changes. At each side of these headings are two squares, one to select the colour of the paper and the other one to select the grain. When grain is selected it somewhat replicates the paper choice options.

The colour choice options allow you to make a base colour before you start work. This is done in more or less the same way as you select colour on your main screen. Choose the base colour in the outer circle and then the tone within the triangle. When you are happy with the choice, select Done in the top right-hand corner. When you make the base colour in this way, the paper retains that colour. It is not possible to rub out the base colour.

Being so painterly, the ArtRage app presents initially a rather bewildering range of options to choose from. But no way is it necessary to use all of these tools. They are explained here for you to understand and then accept or reject as you please.

The Toolbar will now be examined in greater detail to see what interesting things lie ahead.

The Toolbar

Deciding how to exploit this wonderful technology to its full potential is a very personal decision. You may decide to use Art Rage as a sketchbook, or produce finished masterworks that you can sell as prints, mounted and framed, or you may just have lots of creative fun with it.

Each tool has its own unique range of settings. All tools with the exception of Size have their own default settings. The Settings icon is situated at the bottom left-hand corner of the screen. It has the Tool Pod directly above it. Next to Settings there is a Preset icon (*see* Chapter 2 for an explanation of this). Returning to the Settings icon (the two cog wheels) allows you to adjust the tool before you start to work, and also allows you to change settings as you go along.

Although there are a series of structured exercises in this chapter, please experiment and feel playful with all the different effects that the tools offer. Learning will happen most quickly by being courageous and creative. And remember that, if you make a mistake it can be so easily be rectified, so that you are not wasting paper or paint.

Fig. 3.3 This is an example of an image produced with the help of the Fill Tool. This tool is at the very top of the screen. It is used for filling the paper or an enclosed area of your picture with a colour. The line must totally enclose the shape, otherwise the colour will escape.

Changing the settings of the tools

You can change the settings in two ways:

1. Put the stylus on the word Size, or Pressure, etc. and slide it along to change the actual size as indicated by the change in the percentage numbers.

2. Put the stylus on the actual percentage number; a numbers screen will appear. Select the little cross that is in the box showing the existing setting, to get rid of it. Using the keyboard, type in the new percentage for Pressure, Opacity, etc., then select Return.

As you change the setting there is an oblong space at the top of the Settings table; this will give you a very good idea of what to expect from the tool with that particular setting. This mark always appears in blue, whatever colour you have picked.

Explanation of each tool in detail

There are thirteen tools in all, and the functions of each are explained below. There will be specific exercises to help you become familiar with them; experimenting with each tool and its settings should help you gain better understanding and confidence.

1. FILL

The settings for this tool are fairly straightforward. Keep the blend mode at normal. Opacity controls how thick the paint is when it goes onto the canvas. If you are trying to fill just a small area have Spread at a low percentage.

EXERCISE
Using the Fill Tool

Select New Painting.

Use Basic Paper and keep it white. Pinch the screen to bring in the edges. Tap on the Pencil Tool and using a thick line, draw a circle in the centre of the paper, make sure the lines meet. Now tap on the Fill Tool, select a dark colour from the Colour Picker, and tap on your area of white paper outside the circle. The area around the circle will be filled with colour.

2. ERASER

This is probably one of the most useful tools on the Toolbar. It does just what it says. It will rub out all the different kinds of media and can also be used as a tool, for applying white paint.

Settings for the Eraser are quite straightforward and are limited to Size, Pressure and Softness. To get a solid, hard-edged Eraser set the Softness at 0%.

EXERCISE 1
Using the Eraser and looking at Pressure changes

Choosing Paper Basic and leaving it white, use the Fill Tool that you have just learnt about, fill your page with a darkish colour. Use the Eraser, changing Size, Pressure and Softness, to rub out the colour. You will note there is not a lot of difference with Pressure over 50%.

EXERCISE 2
Drawing a landscape with the Eraser

3. CHALK

This tool produces the effect its name implies; it is particularly effective on Canvas Grain Paper.

The settings for this are simple: only Size and Pressure. However, the Pressure setting is vital in the use of this tool. You can create very subtle shading or really bold strokes.

EXERCISE 1
Experimenting with dark over light strokes

Select Canvas Smooth Grain Paper and keep it white. Pinch in. Make marks on the paper using a single light colour, changing Size and Pressure. Select a darker colour and with various settings make varying marks on top of the lighter ones, experimenting with dark over light.

EXERCISE 2
Drawing a head (taking the image from the newspaper)

Fig. 3.4 Try drawing a landscape just by rubbing out with the Eraser. Start with the pressure low about 20% and then gradually increase it. Think of a moonlight scene.

Fig. 3.5 Still using Smooth Canvas Grain Paper, and keeping it white, draw an imaginary head. Start by drawing the outline with Size 20% and Pressure 50%. Gradually fill in varying Size and Pressure. Experiment further with this easy-to-manage tool.

4. CRAYON

In many ways this tool is very like the previous one and can be used to imitate pastel and oil crayons. With light pressure, it interacts well with the grain of the paper.

The settings are straightforward – only Size, Pressure and Softness – and are self-explanatory.

EXERCISE 1
Making marks with the Crayon that exploit colour and tone

Using Paper Hatched and leaving it white, utilize only one colour, making carefully graded marks on the paper and experimenting particularly with low Pressure and Softness. Start at the left-hand side of the screen with light shades and then carefully grade the colours and Pressure, to finish up with almost black on the right-hand edge.

EXERCISE 2
Drawing a bunch of flowers with the Crayon

Fig. 3.6 **Start with Basic Paper and use the Fill Tool to make a sheet of light yellow paper. Then use the Crayon Tool to draw some flowers. Work freely; these are just exercises and should give you the feel of the tool. We can be more careful later on. Try drawing with a line that is just 5% in size but use maximum pressure and softness.**

5. FELT PEN

This tool makes crisp graphic marks and behaves very much like its real-life counterpart. It applies marks that have no texture.

The first three settings remain as before (Size, Pressure, Softness) and although this is a very different tool, changing them has the same effect as the previous tools. The only different setting is Wetness; if you tap on 100% Wetness the intensity of colour is much diluted. It is possible to get some very subtle effects with this tool. The Art Pen setting gives a better quality, bolder stroke, depositing more colour and blending more easily.

EXERCISE
Experimental mark-making with the Felt Pen

Fig. 3.7 **Choose paper basic; do not forget to pinch in the edges of the paper. Keep the surface white. Choosing Size 50%, Pressure 50%, Softness 100%, Wetness 100%, and putting a tick by Art pen, experiment by placing marks of varying sizes on top of each other. See how the marks are very transparent and blend in a pleasing way.**

Fig. 3.8 **Example of a picture by Janet Phillips only using felt-tipped pens.**

6. INKING PEN

There is an extremely large range of settings for this tool, similar to the range of different pens available in a large stationery store. As a result this book can give you only a taste of what is on offer – you must experiment yourself. The Pen gives a precise and solid line and is an excellent tool for illustration. The picture that fronts this chapter was done entirely with the Inking Pen on different settings.

- **Size**: self-explanatory.
- **Blend Mode**: keep this as Normal, otherwise there is a bewildering choice.
- **Taper Length**: this simply means that your strokes have a tapered end. When the taper length is set at 100% the strokes will be tapered at both ends. A lower value means the stroke will taper at one end only.
- **Aspect**: this controls the tip of the pen. 100% Aspect means that the tip is entirely circular or square depending on other settings; 50% aspect creates an elliptical or rectangular tip. In other words, aspect creates a different tip to the pen.
- **Rotation**: this allows you to change the default rotation of the pen tip. If you have 0% rotation the pen lies horizontal to the surface. This is the default setting. As you change the rotation the tip changes its position in relation to the paper.
- **Opacity**: self-explanatory.
- **Smoothing**: this tidies up the lines and makes them flow more easily. With 100% smoothing you can radically alter the shape of your line.
- **Square Head**: if this is ticked it means that the pen tip has a square end.
- **Antialias Edge**: if this is ticked it means that the line has slightly jagged edges, which under high definition represent the minute pixels on the very edge of the line. If you are going to print at high resolution this setting should be ticked.

EXERCISE 1
Experimenting with the different kinds of lines of the Inking Pen

Fig. 3.9 Choose the Basic Paper and keep it white. Initially use black to draw with. Select size 20% and Blend Mode Normal and put all other settings at 100%. With Square Head ticked, and Antilias Edge off, make a series of lines over the picture surface, changing the colour as you go. See how the lines 'move' once you have drawn them.

EXERCISE 2
Imaginary landscape with the Inking Pen

Choose Basic White paper, Size 10%, Blend Mode Normal, Taper Length 0%, Aspect 100%, Rotation 0%, Opacity 100%, Smoothing 0%, Square Head off, Antialias Edge off. These settings give a nice black line to draw with.

Now draw an imaginary landscape.

7. PENCIL

We looked at this tool in Chapter 2; it mimics its real-life counterpart extremely well, but here we shall examine it in more detail. After the complex range of settings for the Inking Pen, the Pencil is refreshingly straightforward. The Smoothing setting will only appear when Precise is ticked and, as with the Inking Pen, it smoothes the line.

The settings here are self-explanatory. Tilt Angle will give you a slightly thicker stroke, like using the Pencil at an angle, and Precise will give you a crisper line.

EXERCISE 1
Drawing an orange with Pencil

Select Plain White Paper and an orange colour. Size 100%, Pressure 100%, Softness 100%, and with Tilt Angle at 70% and Precise off, draw an orange just using pencil strokes. To get the changes of tone just change the colour as you draw. Remember the Undo button.

EXERCISE 2
A small still life with Pencil

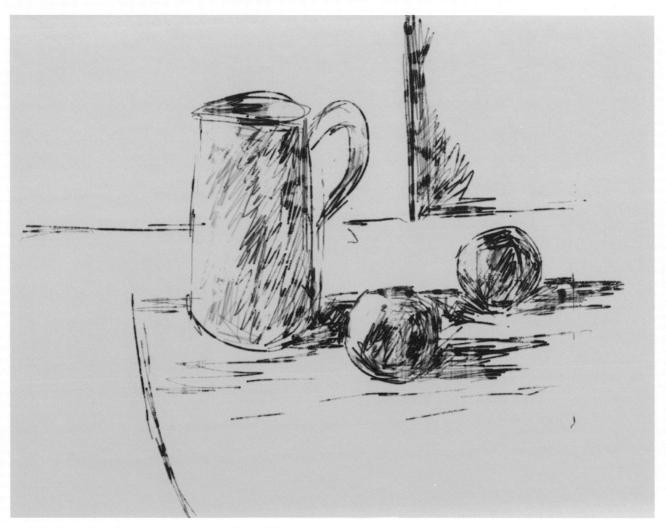

Fig. 3.10 Select Paper Fine and colour it green with the Fill Tool. Choose colour black and with Size, Pressure, Softness and Smoothing all set at 100% and Precise ticked, draw two objects in relationship to one another, e.g. a cereal packet and a bowl.

8. PAINT TUBE

This is a fun tool and when demonstrating the iPad to the grandchildren this is definitely one to show them. Although it can be used on its own it is definitely at its best when used in collaboration with other tools, for example the Palette Knife, which blends all the layers of paint together.

The settings are very easy: just Size and Pressure.

Experimental marks with the Tube Tool

Fig. 3.12 Choose Basic White Paper, and remember to pinch in. With Size and Pressure at 100%, and starting with a light colour make some marks over the paper. Alter the Size and Pressure as you go as well as the colour. Try making some stabbing marks on the screen this will leave blobs of interesting colour.

Fig. 3.11 It can put the paint down very thickly which is ideal for being smeared or blended. However, conversely when the Size is set to a small, it is possible to make a very thin line.

Fig. 3.13 Example of the Tube Tool after it has been smeared with the Palette Knife.

9. ROLLER

As you would expect, this tool places strokes of evenly applied paint onto the paper. It is useful for backgrounds and for covering the surface of the paper quickly in an interesting way. It also interacts with the texture of the paper to produce a variety of effects.

Again the settings are fairly self-explanatory: Size, Pressure, Thinners, Loading and Auto Clean are obvious titles. Auto Clean means that the Roller is cleaned after every stroke.

EXERCISE
Overlaying marks with the Roller Tool

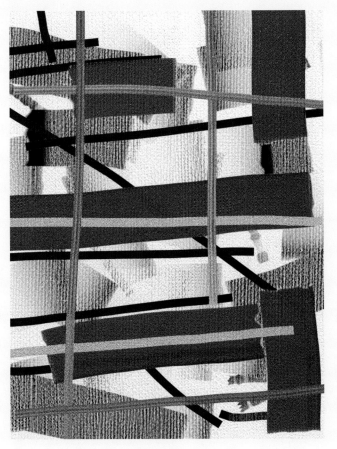

Fig. 3.14 For this exercise choose the Canvas Basic; remember to pinch in. Starting with a large Size Roller 50%, Pressure 100%, Thinners 0%, Loading 100%, Auto Clean ticked and a light colour, make marks all over the surface. See how the grain of the paper comes through. Gradually darken the colour but reduce the Size of the Roller.

10. PALETTE KNIFE

This is an extremely useful tool although it does not work in quite the same way as a palette knife in real life – *you cannot apply paint with it*. It is used only for blending and smudging paint or colour that has already been applied. When you have neighbouring colours that are rather crude or jumpy the Palette Knife is the ideal tool for making them merge harmoniously together. It is also a good tool for getting some spectacular abstract effects.

When selecting the Settings icon for the Palette Knife, underneath the blue line you will see Size and underneath that there five little icons representing the different kinds of knife you can use. The first four icons have just Pressure and Size settings, but the last icon on the right has a large number of options. By selecting each one with your stylus the small blue line at the top of the table will indicate the type of mark you can expect. The name of each kind of knife is shown on the right-hand edge. By tapping on the far right knife (Wet) you get a different range of settings. Wet turns the Palette Knife into a water sprinkler, which sprinkles droplets of water onto the canvas causing the paint to spread and expand. All the other options (except Pressure) need to be experimented with, so you can actually see, for example, what Drip Spike really means.

EXERCISE
Making some marks with the Tube and smearing with the Palette Knife

Choose Plain White basic paper and using the Tube tool and any mid-tone colour make some marks over the paper surface. Choose Size 50%. Then go back to the Palette Knife. Tap on the far right icon to select Palette Knife Wet, Size 100%, and then take your stylus over some of the original tube marks. You will get a lovely smeary effect. Now change to a different Palette Knife shape. Try the one on the far left of your table – the name for this one is Flat. Again, place the stylus over these marks and smear again and see what effect you get. There is plenty of scope for experimentation here.

11. AIRBRUSH

This tool behaves very much like a real-life airbrush, spraying fine layers of colour on top of one another or onto pre-existing subject matter. The result can be extremely subtle and beguiling, and unlike a real airbrush, the iPad version won't become clogged with paint and need lengthy cleaning.

Many of the settings we have encountered before, and are self-explanatory (Size, Pressure, Tilt Angle, Taper Length, Opacity and Airflow). Blend mode should be left as normal. As you move the settings for the Airbrush with your stylus the small area at the top of the chart will give you a good idea of what kind of stroke to expect; remember the stroke always appears in blue whatever colour you have chosen.

EXERCISE 1
Making marks with the Airbrush

Fig. 3.15 Choose Hatched paper and leave the surface white. Select a light colour. Size 100%, Blend mode normal, Pressure 50%, Tilt angle 100%, Taper length 50%, Opacity 100%, Auto flow off. Make marks all over your picture surface. Tap the colour pod and the tool pod so you can see the whole paper and make the lines go to the edge of the paper. Gradually increase the tone of the colour as you make further marks. Note by placing two lines side by side you get a wonderful 3D effect.

EXERCISE 2
Using just one colour

Fig. 3.16 Choose Paper Special Coarse and leave it white. Pinch in. Choose Size 80%, Blend Mode Normal, Pressure 50%, Tilt angle 100%, Taper length 0%, Opacity 100%, Auto flow off. Choose a mid-tone colour and make lots of different strokes with the stylus over the paper.

12. WATERCOLOUR

Again this tool behaves very much like its real-life counter-part. The brush paints delicate strokes of wet pigment that blend with other paint marks and react to the wetness of the paper.

These settings are familiar as they have been mentioned before in conjunction with other tools and are mainly self-explanatory. Size dictates the size of stroke and Pressure dictates how firmly the brush is pressed against the paper. Thinners controls how much water is in the brush and Loading how much paint you actually pick up. Colour Bleed dictates how much the colours will run into each other. Paper Wet determines how wet you want the paper to be. Select Insta-Dry if you want the paper to dry instantly and Auto Clean if you want the brushes to be washed after every stroke.

EXERCISE 1
Making marks using the Watercolour Tool

Fig. 3.17 This picture was produced on white watercolour paper using the Watercolour Tool.

EXERCISE 2
A simple landscape with Watercolour

Choose Watercolour Paper and leave the surface white. With a fairly large brush, at least 60%, Pressure 50%, Thinners 50%, Loading 100%, Colour Bleed 50%, Wet paper and Insta-Dry off, and Auto Clean on, try to paint a country landscape. If you cannot imagine one, copy loosely from a postcard. The overall impression should be loose.

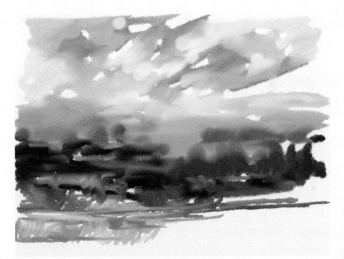

Fig. 3.18 **Example of a watercolour landscape.**

13. OIL BRUSH

This is a very exciting tool for the established painter. It shows ArtRage at its best, with excellent simulation of the stroke of the brush. We looked at this tool briefly in Chapter 2, but now we can look at it in more detail. I would defy anyone not to enjoy putting down marks of thick luscious oil paint on the screen and using the Insta-Dry option to make the marks go cleanly on top of one another.

The various settings of Size, Pressure, Thinners, Loading, Insta-Dry Auto Clean and Square Head have been described previously and should now be self-explanatory.

EXERCISE 1
Experiencing mark-making with the Oil Brush

Choose Canvas Basic, which has a nice grain to it. Keep the surface white. Start with Size 50%, Pressure 50%, Thinners 0%, Loading 50%, Insta-Dry off, Auto Clean on, and Square Head off. Just experiment with different kinds of marks all over the paper surface. Change the settings as you go, but keep to one colour so that you can really see how the marks vary. Use 75% Thinners sometimes to dilute the colour.

Now that all of the thirteen tools have been described with their various settings, we still have to look at the Presets that are available for them. But before you look at the Presets, just experiment and enjoy the tools and get to know the settings, seeing how they interact with each other.

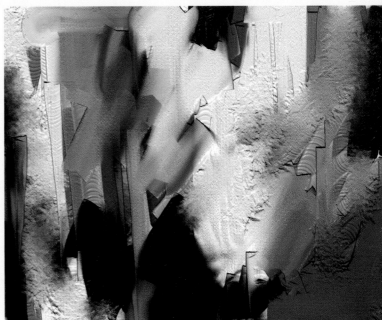

Fig. 3.19 **Example of work done with the Oil Brush.**

EXERCISE
How all the tools can be used together

Choose Paper Basic and make a sheet of coloured paper with the Fill Tool. Then, using the Roller Tool, make some marks on the paper surface and add some Crayon marks on top of the Roller marks. Next, rub part of it out and add some further marks with the Oil Brush.

Presets

The Presets icon is next to the Settings icon and is second from the left side of the screen.

Presets provide a way of getting the effect you want without changing all the settings yourself. For example, with the Oil Brush, if you wanted a thick gloss effect, the Preset would ensure that the settings would change automatically to create that particular effect. Of course it is possible to change the size without altering the other settings. Try it out yourself by tapping on the Presets for the Oil Brush and see how the settings change according to which Preset you have pressed. Another tool with interesting Presets is the Inking Pen –you need to scroll down to see the full collection. Do look at these and experiment with them.

Looking at each tool in order we will see which Presets are available. I am explaining this now, even if you are feeling a bit overwhelmed, as some of the Presets are very useful and you should be aware of their possibilities. It is possible to come back to this later, it is not essential to have this information now.

When learning this it would be useful to have your iPad open and tap on each individual too Preset so you can actually see them for yourself.

1. FILL
No Presets.

2. ERASER
There are three Presets here for selecting the marks the eraser makes.

3. CHALK
No Presets.

4. WAX CRAYON
No Presets.

5. FELT PEN
Six Presets provide an interesting selection of mark-making possibilities.

Presets of the Inking Pen

Choose Basic Paper and leave it white. With the size and setting constant, select each Preset and make a series of marks on the one sheet of paper to show the different Presets. This will illustrate the range of possibilities: which these could be printed off as an *aide memoire*.

6. INKING PEN
There are eleven Presets, so many that you need to scroll down to see them all. They are all useful but some are quite similar in outcome to others. Just go down the list and experiment.

7. PENCIL
Eight different Presets; scroll down to see them all.

8. PAINT TUBE
No Presets.

9. ROLLER
Four Presets here: very effective and great fun, especially Speckled Line.

10. PALETTE KNIFE
There are thirteen different Presets and their names give clues as to how they react on the paper. Harsh Chaos and Frosted Spots are fascinating but you should try the different options for yourself.

11. AIRBRUSH
Four Presets, of which Tendrils is especially effective.

12. WATERCOLOUR
Twelve Presets here; scroll to see the whole selection. Although all of them are useful, they are sometimes hard to manipulate.

13. OIL BRUSH
Twelve Presets. They are a great asset to iPad painter and their names indicate what they do. Thick Gloss is a particularly exciting one.

At this stage it will be clear that the possibilities for each tool are almost endless according to the Presets and Settings you employ.

One suggestion would be to keep the size and settings the same and then experiment with the tools that have lots of Presets.

Storing pictures of some of these effects in the Gallery provides a reminder of particular Presets.

Making your own Presets

This is quite a complex process; if it is a step too far you can easily skip this section and come back to it later when you feel more confident with the iPad. Although it is not necessary to have this information yet, it fits comfortably into this chapter.

All the Preset icons offer the opportunity to make and store your own settings, enabling you to access easily and quickly an effect you really like.

To make a Preset, make sure you have all the right settings in your panel. Then select the Presets icon. A table will appear which says New Preset. Select this and a small table will appear in the centre of the screen. For the Chalk Tool it will look like this (see above).

After making this selection press the tick. By selecting the name of the tool on the chart, there will be the opportunity to name the Preset; when you have done this, select OK. This then stores this setting in your Preset box. Check again that it has been stored correctly by selecting Presets again and then selecting your newly made Preset. Then select your Settings icon and check that this is what you started with. It is possible to have as many Presets as you wish.

Fig. 3.20 When tapping on the picture of the Tool, there will be a choice of a Default preview image or a Sample preview image. The first choice represents the standard image, while the second choice gives you the opportunity to move the table onto a piece of the picture that truly represents your Preset. By tapping on Sample Preview image you can move the chart over the piece of the picture you want.

EDITING A PRESET

If you want to remove a Preset from your list, select Edit, which is at the top of the list. Each Preset will then have a little circle in the top left-hand corner of its box. Tap the circle of the Preset you wish to remove and a little tick will appear. There is a rubbish bin icon in the top right of the small screen; tap on this and the Preset will disappear. Then tap outside the box to make the Preset table disappear.

A great deal of information has been covered in this chapter; it is advisable to spend some time familiarizing yourself with the concepts introduced – in other words, master the scales before you play the concerto!

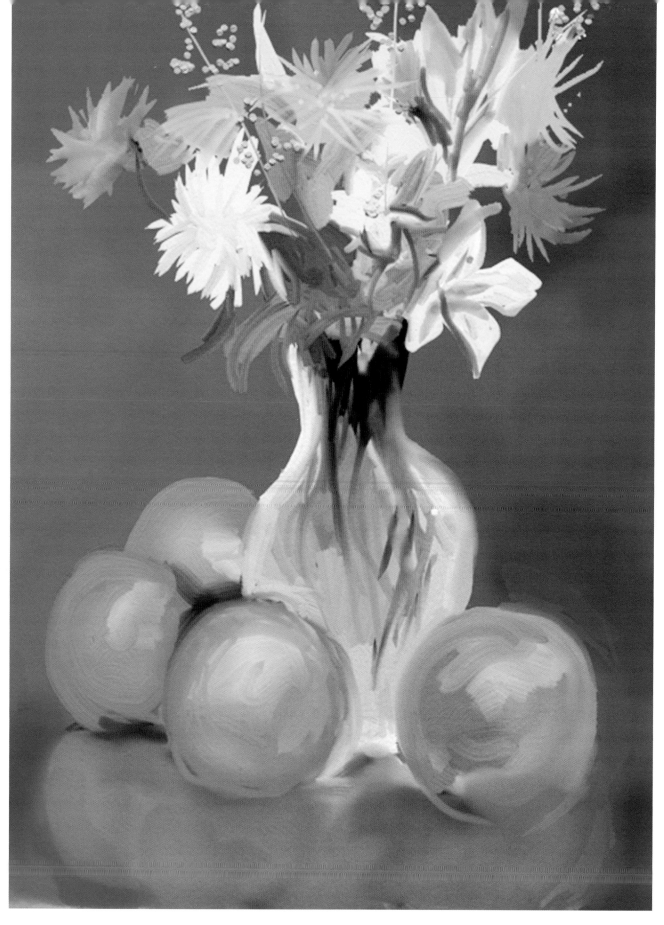

Fig. 4.0 *Flowers and Oranges* by Janet Phillips. The still life of a vase of flowers and oranges was put on a piece of card with a reflective surface to add interest to the overall arrangement. The picture was produced with layers. This process will be described in more detail later in the book. Janet drew the sketch layout of the still life with the Chalk Tool on the first layer. The background was made on the second layer using the Chalk Tool and the Palette Knife for blending. The flowers were drawn with a mixture of tools including Inking Pen for the chrysanthemum petals and Oil Brush for the daffodils. This still life demonstrates excellent use of complementary colours and a well-balanced composition.

Chapter 4

Still life

No matter what the illusion created, it is a flat canvas and it has to be organized into shapes.

DAVID HOCKNEY

The theme of still life lends itself readily to work on the iPad. It is quite different from landscape painting, where often we try to represent depth. Here we are more likely to be concerned with picturing objects and their relationship to each other.

Drawing and painting of still life has been around for thousands of years; even the Egyptians painted pictures of fruit and vegetables on their tomb walls many thousands of years ago. Much inspiration can be gained by looking at classical still life pictures, as they give hints on how we might interpret a bowl of apples or a pot plant on a windowsill. You could even set up a still life in the manner of Cézanne for instance.

In the book *David Hockney: The Bigger Exhibition*, a number of small still-life pieces are showcased (pages 147–8). All these pictures have the charm of immediacy, the artist just seeing something around him and drawing whatever was at hand: a group of oranges in a bowl, a lily on the windowsill, a vase of sunflowers. Note that in all these lovely illustrations there is an awareness of composition and how the objects are placed within the rectangle. All the illustrations you see in the Hockney book were done with the Brushes app. Although we are concentrating on ArtRage, the ideas they give us for subject matter are very useful.

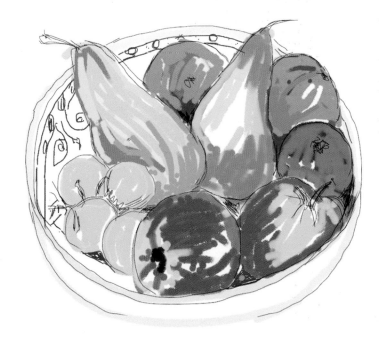

Fig. 4.1 This still life picture was produced by Emer Clarke-Hutton early on during an iPad course I was teaching. Drawing directly from nature she produced this charming image. Initial outlines of the fruit and bowl were drawn with Inking Pen and then the fruit filled in with Felt Tipped pens. Final details on the bowl were also done with the Inking Pen.

Setting up a still life

When setting up a still life for painting and drawing, you are placing a series of objects together. It is best if these objects bear some relationship to one another. They could relate in terms of colour, for example – it is amazing how varied and exciting a single-colour still life can be. It also means that the composition is harmonious, with an element that ties all the objects together.

Returning to colour, think about the use of complementary colours as you set up your objects. For example, you could place red flowers on a green cloth, or oranges on a blue cloth.

The objects chosen could also be related by the use to which they are put, for example, a group of cooking implements or garden tools. Or it could be just as well be a group of unrelated objects that just happen to fit rather well together.

All these various hints give you a head start in making a successful picture. Choosing your objects carefully is very important. As you set them together use a small cardboard window to look through to make sure there is a balanced composition – in other words, there should be a variety of small and large shapes and a good mixture of texture and colour to provide visual interest. When the picture is analysed graphically there should be an interesting balance of horizontal and vertical lines.

Think carefully too about light. A strong light from one side will help with your drawing and painting skills and make it easier to represent form. Do spend time setting up a still life, as a good set-up is essential to the success of your picture. If there is a bunch of flowers in the still life it might wither and die over time, so take a photograph at the beginning to use as a reference long after the flowers have gone.

Fig. 4.2 **Example of related objects** *After the Hike* by Angela Whitehead. This lovely pencil drawing is a case in point. Angela, who is a keen walker, set up this still life and drew it quite simply with the Pencil Tool; note how she has arranged the objects carefully to relate to each other and make an interesting set of shapes.

Drawing a single object

To start do a simple exercise with just one object.

Choose a plain green apple and place it on a flat surface with strong light from one side.

Draw this apple with the Pencil Tool. Choose Basic White Paper, Size 50%, Pressure 50%, Softness 100%, Tilt Angle 0%, Precise crossed, Preset Soft Tip.

Fig. 4.3 Draw the apple in a simple way including the shadow. Let the lines suggest the form of the apple.

Fig. 4.4 Now draw the same apple with the same settings but this time choose Paper Rough and note the very different effect that this gives.

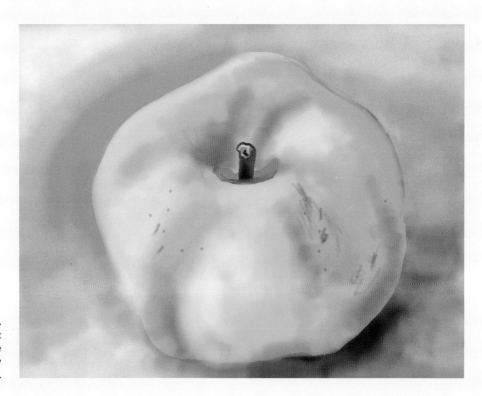

Fig. 4.5 *Apple Study* by Janet Phillips. Next try some simple colour. Janet produced this lovely study of an apple just using the Chalk Tool on a variety of settings.

Painting a single object

Select Canvas Basic, Tube Tool, Size 45%, Pressure 50% (Fig. 4.6).

Next select the Palette Knife Tool, Default Settings, Type Wet, Size 40%, Preset Frosted Spots.You can experiment further using different tools to suggest a three dimensionality (Fig. 4.7).

Fig. 4.6 Draw an orange, copying the same tonal structure that you see on the orange. Make marks that suggest the structure of the orange. It will look very crude at this point.

Fig. 4.7 Remember that the kind of mark the Palette Knife makes will appear on the top blue line of the settings table. Blend all the colours together so you have a pleasing three-dimensional form. The edges may be a little hairy from Frosted spots. You need to rub these off with the Eraser on small size.

Putting objects together and using colour

Try to replicate this picture (Fig. 4.8) using Paper Basic and the same tools; perhaps draw just one pear but do remember the shadow.

Having done three pears so well, Angela repeated this image (Fig. 4.9) in a more complex still life. Carefully placing the fruit on the plate she began to map in the shapes with the Wax Crayon tool on a small size. The picture was made on Paper Basic and the surface remained white. When she was pleased with the arrangement within the picture frame she began to fill in the shapes more solidly, working with the tool on a very small size and low pressure (as in the previous picture). Subtle blending of the colours in the fruit and the shadows on the plate were done with the Palette Knife. Finally, the Fill Tool was used to make the purple background.

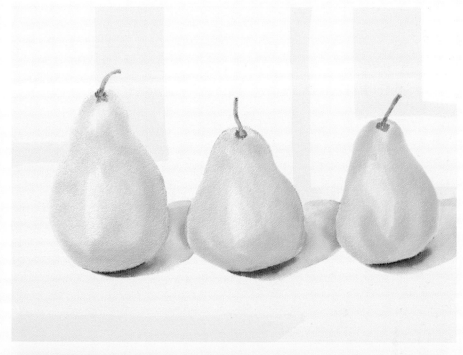

Fig. 4.8 *Pears* by Angela Whitehead. This picture of three pears was made using the Roller for the background and then the Wax Crayon Tool to draw the pears. The different shapes of the pears in relation to each other are what makes the picture interesting. Low pressure was used to replicate the gentle changing tones of the fruit. The dark tones underneath the fruit were crucial to suggest the three-dimensional quality of the form.

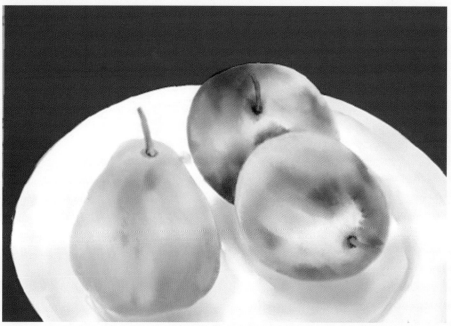

Fig. 4.9 *Fruit Plate* by Angela Whitehead. If you have found an image that you can paint successfully, it is quite a good idea to repeat it again in a slightly different form. In this way you can reinforce what you have learnt.

A more graphic interpretation of what you see

Experiment with different kinds of fruit and different backgrounds.

Fig. 4.10 In this exercise try more graphic marks and, using the Chalk Tool, draw some simple fruit forms; use the Fill Tool to fill them in with solid colour.

EXAMPLE OF A SIMPLE STILL LIFE BY ELAINE FEAR

The next series of still life pictures illustrates rather well some of the principles we have been talking about. It shows shapes in relationship to each other on a flat surface and utilizes very simple forms.

The pictures above show how you might set up and complete a simple still life. When you start, do not challenge yourself too severely.

Fig. 4.11 Elaine set out some coloured glass vases with a hand-thrown bowl and a red apple placed inside it. All this was placed on a pale turquoise cloth on a table. The set-up was done in the evening with electric light mainly from the left.

Fig. 4.12 To start with Elaine chose Paper Basic and made the background colour of the paper with the Fill Tool; the colour was chosen to tone in with the objects she had selected. Initially using Pastel Tool, she tried to get the lustre of the blown glass vase on the left.

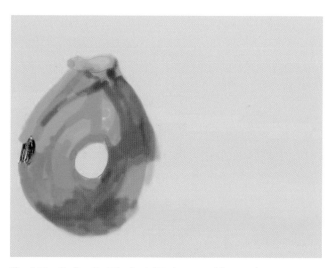

Fig. 4.13 Feeling that the Pastel Tool was too blunt and opaque, Elaine swopped to the Airbrush Tool and decided that this was far more suitable. The Eraser was then used to add highlights to the green vase, which improved the effect.

Fig. 4.14 The Airbrush was used again to add spots on the green vase and to start off the blue vase. The basic shape of the blue vase was drawn with the Felt Tipped Pen and then filled in with the Airbrush, varying the opacity continually to get a 3D effect.

Fig. 4.15 Further dark shadows were added to give more form to the green vase and a highlight around the neck of the blue vase was made by the Eraser. The Airbrush was used to make the outline of the white bowl; next the apple was drawn with the Crayon and then filled in with Airbrush to make it more opaque. After that a half-highlight was added with a lighter coloured Airbrush.

Fig. 4.16 The cloth was made more solid with the Airbrush, varying the tone to represent shadows on the surface; the subtlety of the Airbrush came into its own again for the shadows inside the bowl. The shadow on the green vase needed some further work as it had lost its shape somewhat. The shadows also needed darkening under the bowl and behind the blue vase. Elaine said she enjoyed working on just one layer; it made her think through the drawing more carefully. This sequence of pictures shows how you might set up and complete a simple still life. When you start, do not challenge yourself too severely.

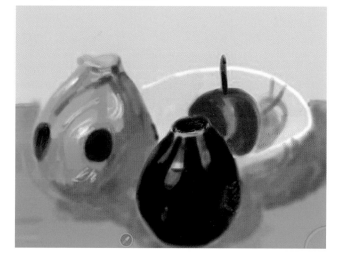

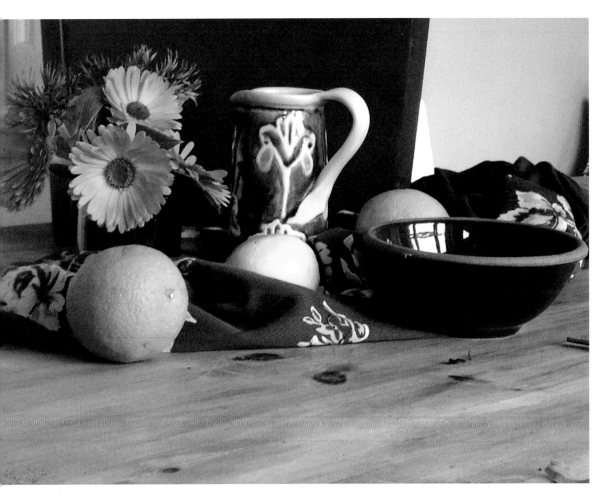

Fig. 4.17 This still life of more complicated objects was set up in my kitchen. Objects were chosen with the idea of complementary colours. The orange marigolds from the garden, oranges and a lemon, a blue bowl, a blue jug and a blue cloth were arranged. As the still life had flowers in it, a photograph was taken, this was intended as a record of the objects, especially the flowers, but there was no intention to copy it.

MORE COMPLICATED STILL LIFE

There are real flaws in the composition of the photo above (Fig. 4.17); the foreground shape of the table in particular is far too dominant. Seeking to rectify this I set about drawing the still life to rough out the composition, aware of horizontal and vertical lines and negative shapes and how the whole composition would sit within the rectangle. The Pencil Tool was chosen and Paper Basic was selected.

The Felt Pen can be used to achieve subtle tones and I thought it would be a good imitator for the watercolour. The tonal sketch was printed for reference so it could be used when the final picture was being painted on the iPad. The line sketch was saved to Photos and later imported (using the Tracing function) so it could be painted over.

The size of the Pen varied but the Pressure, Softness and Wetness were always high. The Art Pen was ticked. Preset was Blending Markers which allowed all the colours to blend superbly. Initially I drew in quite lightly and then gradually filled in more solidly. Putting light over dark was exciting and made some lovely textures within the picture. The composition changed slightly to make the image more balanced. When the colours became too muddy I used the Eraser on a small setting, to get back to the white paper. The background colour at the sides of the blue cloth was changed a few times (it was beige at one point) till I found the colour and the tone which best fitted into the composition.

This series of pictures shows that good preparation does pay off, and although things do change from sketch to sketch, there is a firm basis on which to build. This still-life arrangement will appear again in Chapter 6, Abstract.

Fig. 4.18 First compositional sketch. In appraising the drawing, I thought that the marigolds were too dominant and that the whole picture needed more air and space around it, so I made a new drawing, pushing the picture back in the picture plane.

Fig. 4.19 The second attempt at composition. This arrangement was much more satisfying, with a good relationship of shapes and a pleasing mixture of verticals and horizontal lines. Next I felt I needed to know more about the darks and lights in the composition and, after saving a copy of the drawing, went on to just wash in darks and lights with the Watercolour Brush.

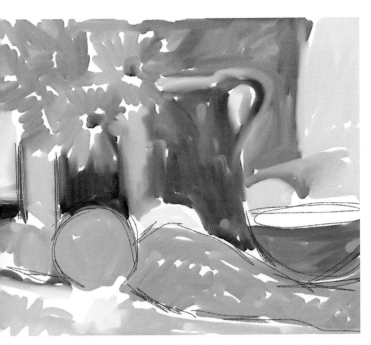

Fig. 4.20 Tonal sketch of still life. This is by nature very sketchy, but I wanted to illustrate some of the preparation that you could go through before embarking on a major picture. Good preparatory work is a major factor in the ultimate success of the final image. The looseness of the watercolour in this sketch influenced my choice of tool when finally adding colour to the picture.

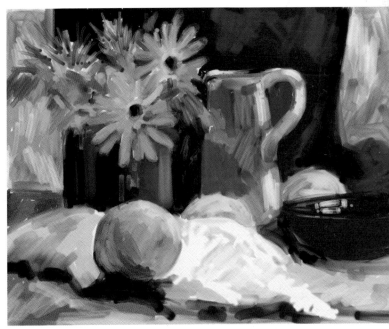

Fig. 4.21 The blue and orange still life.

Fig. 4.22 This shows the enlarged screen allowing the details to be worked on, the size of the Pencil tool is just 2% and the Preset is Soft Tip.

The next set of pictures illustrates a really delicate and painstaking approach to the subject of still life. This gentle and soft group was set up with a chiffon scarf, a glass bottle and a silver pendant. All the objects were chosen to complement each other and to illustrate the contrasts between the texture and the softness of the cloth, the hardness of the glass and the delicate qualities of the pendant.

The bottle was softened, to make it more glass-like and transparent, using the Eraser Tool on very low Pressure. Preset Soft Eraser was used too. Some of the shadows were darkened slightly to give more form to the cloth. From the amount of detail in this picture it will be clear that it took several hours to complete. The final picture shows how fine the iPad work can be.

Fig. 4.23 Paper Basic was chosen and the background colour was made by using the Fill Tool. For the cloth and the bottle the Chalk Tool was chosen, the colour on the cloth being suggested with the Chalk on very low pressure. The Pencil Tool was used for the pendant and the palette knife Tool used for a small amount of frosting on the cloth.

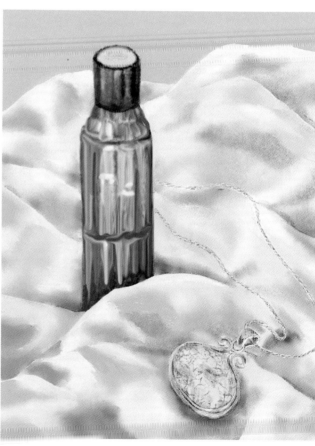

Fig. 4.24 The tones of the cloth were strengthened with the Chalk Tool, but Angela decided that this was too strong and she went over it again with the Eraser on low pressure.

Fig. 4.26 For the final picture, a number of colours for the background were tested using the Fill Tool. A turquoise background was eventually chosen as the most appropriate to tone in with the colour of the pendant.

Fig. 4.25 This picture shows a greatly enlarged screen and illustrates how it is possible to work in the finest detail.

CHANGING THE BACKGROUND COLOUR

The two still life pictures below were made from the same still-life group and illustrate how the inclusion of a dark background dramatically changes the picture; they were painted with very similar tools.

After carefully arranging the composition, the oranges were drawn with the Chalk Tool and the purple pot with the Watercolour Brush. Shapes were further defined with the Inking Pen to bring out their form and shape.

Mary set up the still life in her kitchen and carefully chose the objects, the colour of the marrow flower merging well with the pepper.

Still life provides a wonderful source of inspiration for drawing and painting. Junk shops can be a good place to find highly unusual objects and if they are chipped or broken they can be picked up cheaply and provide very stimulating visual material. However, it is often the case that you can find real beauty in very simple objects that are just lying around the house.

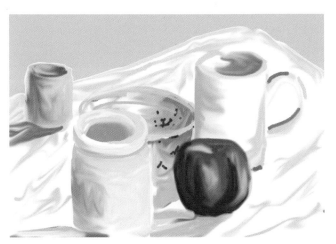

Fig. 4.27 *Still Life with White Mug* by Mary Langham. This picture shows a low tonal key overall and has exciting compositional aspects.

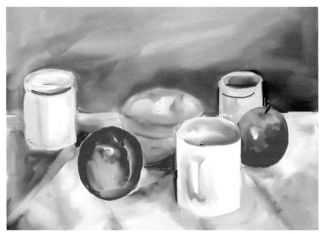

Fig. 4.28 *Still Life with White Mug* by Janet Phillips. The same still life composition, but painted using much darker tones and a dynamic dark background.

OTHER STILL LIFE PICTURES

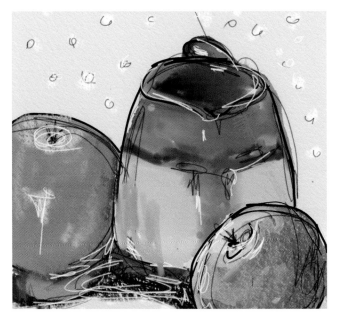

Fig. 4.29 *Kitchen Still Life* by Margaret Gill. Margaret made this still life picture on a green ground using the Fill Tool to make the coloured paper.

Fig. 4.30 *Still Life* by Mary Langham. This still life by Mary illustrates well the beauty of ordinary items around the house.

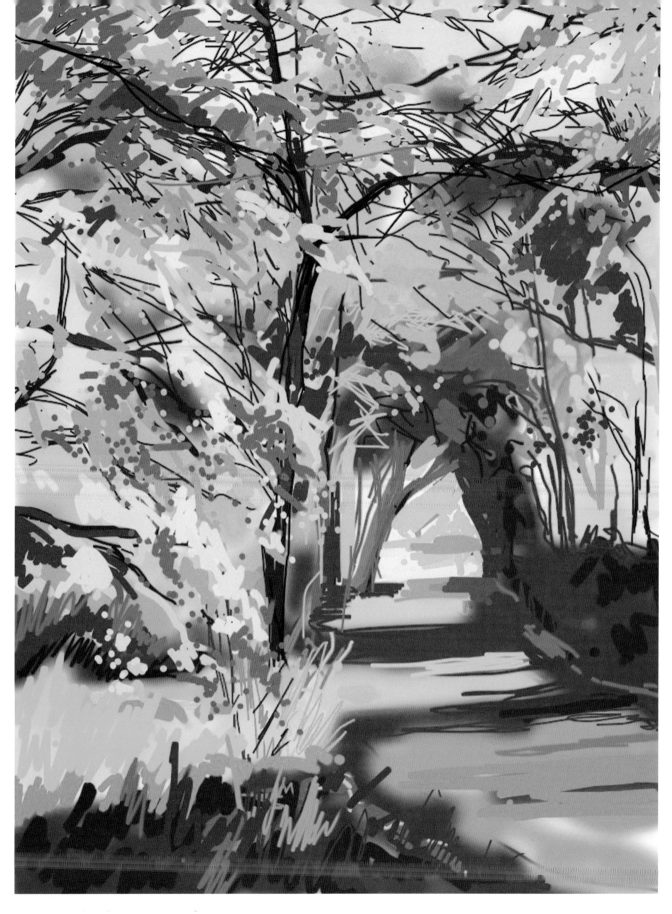

Fig. 5.0 *Autumn Sunshine*. Living in a very beautiful area of England, I am constantly bombarded by the beauty of nature all around me; so when I saw these autumn trees just down the road, I knew they had to become a painting on the iPad as the colours were just so inspiring. Firstly I took a photograph to record that particular light (I loved the shadows making such strong lines across the road), and then started to map in the main lines of the composition with the Pencil. Deciding not to use layers, I simply Airbrushed the sky in over my rough drawing on fairly low opacity so I could see the drawing through. The Chalk Tool was then used to suggest the colours of the foliage and the foreground established with a strong green. The light was now changing so I retired home to work from the photograph. To make the small branches the Inking Pen was used; the picture was a lovely memory of a special day in autumn.

Chapter 5

Landscape

Of course you can still paint landscape – it's not been worn out.

DAVID HOCKNEY

t is a joy to travel to do some landscape painting, with only an iPad, a stylus and a chair to sit on. (Normally there is a car full of gear and the worry that perhaps that tube of Titanium White might run out and did I bring enough paper?) With this tool you have the world at your fingertips: watercolour, oil crayon, oil paint, inking pens, felt tips and much more, all encompassed in this tiny tablet.

All the major landscape painters have derived their inspiration from outdoor scenes: John Constable made some fabulous sky studies outside the studio and abstract artists like Ben Nicholson and Nicolas de Staël derived the ideas for their pictures from real life. To go out into nature and draw and paint is often the beginning of some wonderful work. So I encourage you to take your iPad outside the studio and record what you see or do some actual *plein air* painting on your iPad. There are some marvellous examples of Andrew Marr doing just this in his book *A Little Book about Drawing*. He simply records what he sees, where he is. He is a consummate draughtsman with wonderful drawing skills and he makes iPad drawing look easy.

In this chapter on landscape painting, it would be unjust not to mention the landscapes of David Hockney, who, although he is now over seventy, goes out to draw directly from nature on his iPad and also uses these images in his paintings. His large iPad prints at the Royal Academy Exhibition of 2012, entitled *The Arrival of Spring* were all drawn near his home. It is quite obvious when you look at them that the colours are

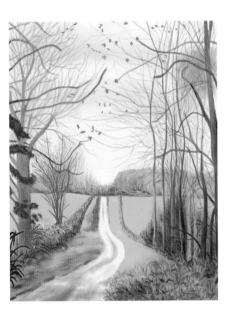

Fig. 5.1
From a landscape by David Hockney, copied by Angela Whitehead. While carefully copying this, Angela said she learnt much about Hockney's working methods.

deliberately unrealistic, yet they evoke all the atmosphere of the woods in springtime. And underlying all his iPad work is his superb drawing ability.

Hockney used Brushes 2 for his landscapes and since this app is no longer available it is difficult for us to try to reproduce them. However, the picture above is a small copy of a David Hockney landscape that was originally painted with Brushes 2 (copied here using the ArtRage app). Although some of his oil painted landscapes are highly stylized, the textures, colours and patterns come from real-life observation. His work encourages us not to be exact about colour and reality, but to use the shapes we see in the landscape in a personal way.

So where to start with your landscape painting? The iPad screen is currently impossible to use in bright sunlight. On a sunny day you will need to find some shade. For good visibility on the screen, try to get away from overhead light. Good places to sit are in the car, looking out of a window, beneath some overhanging branches, or in the shade of a building.

EXERCISE 1
Making simple landscape sketches

Start with some simple sketches of various outdoor scenes and just using the Pencil Tool on Basic White Paper, make some different kinds of sketches. Your choices will be determined by where you live. Try distant views, views involving buildings, views with people, and views with trees or other vegetation. Resist using colour in these initial stages and try to keep the drawings simple.

In this exercise, if you lack inspiration around you, try to find some sketches by an artist you admire and copy them. Van Gogh did some excellent landscape drawings. Try to draw to the very edges of the paper so that you get a good idea of composition. Classical landscape composition nearly always involves a road or a river at the front of the picture to lead the eye into the picture. A strong centre of focus is made by tonal changes; to give the illusion of depth on the canvas, lighter tones are used in the background. The artist should aim to lead the onlooker around the scene. Look at John Constable's famous picture, *The Hay Wain*, where he uses the line of the riverbank to lead the eye in and the delicate painting of the trees in the distance to provide depth.

EXERCISE 2
Using simple tools with more detail

Now it is time to try something a little more complicated and to consider the aspects of composition described above: foreground, middle ground and distance. Search out a scene near you that has these aspects and sketch it (if this is too difficult, find a picture in a magazine). Stay with black and white and try the Pencil Tool or the Inking Pen.

For the sketch below I decided I would use black Pencil on White Basic Paper, Preset Soft Tip. Size varied throughout the drawing and the Eraser was used frequently. The whole sketch was done quite quickly with the intention of working further on it at home. Don't forget to use the Undo button if there is something you do not like.

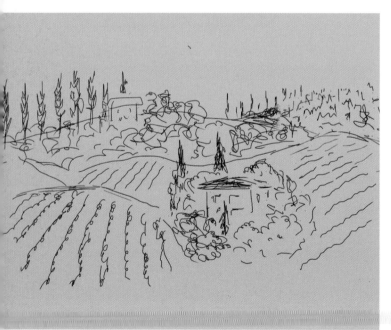

Fig. 5.2 *Italian Landscape* by Wendy Robinson. Wendy made this delightful simple sketch when she was in Italy. Drawing very directly with pencil on coloured paper, she was able to evoke the atmosphere of the Italian countryside.

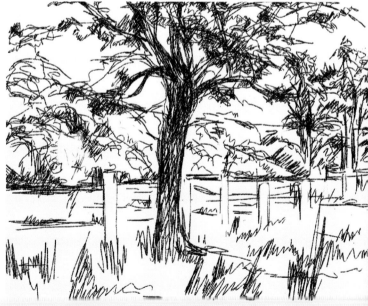

Fig. 5.3 The view beyond the tree. This is an example of a pencil sketch done *en plein air*.

EXERCISE 3

Adding colour to your black-and-white sketches and drawing with colour

Now you are getting used to drawing landscapes and are more familiar with the kind of shapes and textures found in nature it is time to introduce some colour.

First, try adding some colour to your existing drawing. In the example shown here (Fig. 5.4) I have used the Watercolour Brush.

Try also drawing with the Felt Pen, Inking Pen and Watercolour Brush. Still keep the drawings quick and direct. In these two vibrant sketches, Emer has used the Inking Pen and added some Felt Pen. Both sketches were done directly from the subject matter.

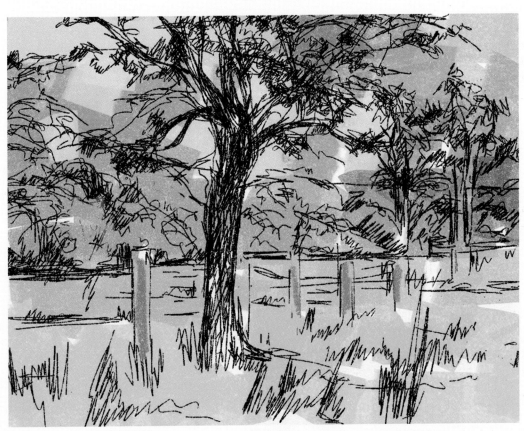

Fig. 5.4 The same sketch, but with colour washed in with the watercolour brush.

Fig. 5.5 *View Across the Fields* by Emer Clarke-Hutton.

Fig. 5.6 *Marlborough College* by Emer Clarke-Hutton.

EXERCISE 4
Longer studied drawing outside, using colour

For this next exercise, keep in mind the tonal composition and colour when you take your iPad out to paint and draw in the landscape. Select a comfy chair to sit on, as it is hard to draw with the iPad while standing up. Choose a view that has some depth with something strong in the foreground and find yourself a shady spot. Choose Hatched Paper, and remember to pinch your screen so that you can draw to the edges. Now, with the Pencil Tool, make a sketch of what you can see. Remember that you can save this to the Gallery and make another sketch with a different composition and then compare the two. Once you are happy with your pencil sketch, start to introduce some colour.

In the example shown below, only the Chalk Tool was used, as it is really simple, with only two settings and no Presets. With Size and Pressure at 50%, start to work from the back of the picture to the front, remembering that you can easily draw over your existing Pencil lines. Change the size of the Chalk Tool as you work and use the Undo button freely when you are not happy. Enjoy using the different tones of colour, and see how easy it is to make subtle changes. Gradually move to the front of the picture, making sure your tones and colours get stronger. To finish the picture make the size of the Chalk Tool much smaller and put in the details.

Fig. 5.7 A simple example of a landscape using only the Chalk Tool.

EXERCISE 5
Different interpretations of the same basic sketch

These illustrations show how a pencil sketch, done in a standard white paper sketchbook, can be developed into a variety of iPad pictures.

This sketch below (Fig. 5.8) was done *in situ*. I was interested in the strong verticals of the trees against the horizontal lines of the green meadows; the overhanging branch was an interesting diagonal in the whole composition. Using the iPad I wanted to interpret the sketch in a fairly abstract way but still hold on to the basic composition.

Fig. 5.8 **Landscape sketch done in a sketch book and drawn at Henley-on-Thames.**

Fig. 5.9 **This illustration shows how the original pencil sketch was transformed into an iPad picture.**

To start the picture opposite bottom left, I chose White Paper Basic and pinched in before I started drawing. The whole picture was done with the Tube Tool and the Palette Knife, as follows: Tube Size 35%, Palette Knife Size 50%, Pressure 100%, Wet Setting, Preset Frosted Spots.

The light blue sky was put down first and then smoothed out with the Palette Knife. Then, using a light green colour, the background trees were added and the area smoothed with the Palette Knife. Some darker and lighter tones were added to give some form. After this the light green meadow was painted. The three foreground trees were drawn and a lighter colour placed down the left-hand side to give some form to the trunks of the trees; then, with a smaller Tube size, some marks were made for the foreground and some warmer tones introduced. Tube marks were fairly haphazard to represent the texture of the grass. Clearly visible are blobs of paint, which were made by simply tapping the screen with the stylus. The branches and light grass in the foreground were made by taking the Tube Size to between 2% and 15%. At 2% the Tube makes a marvellously thin line. Even though the marks are quite abstract, the landscape has conformed to the standard conventions of foreground, middle ground and distance. It was only towards the end of making this picture that I decided that the eye should be pulled more strongly towards the centre and added the light beige stripe.

Just to show you the versatility of the iPad I have included another interpretation of this same sketch done by a fellow student (Fig. 5.10). Janet worked mainly with the Oil Brush for the larger areas. Some details were added with the Wax Crayon. The Inking Pen was used for the grass and the Palette Knife was used to blend the foreground grass.

In another version (Fig. 5.11), I chose Canvas Basic to work on. The Chalk Tool was selected in pink to sketch out the initial composition. Shapes were then blocked in with solid colour. I rather liked the unfinished look to it so I decided not to cover all the white paper. The print was framed with the white showing.

In art there are always many ways of doing things. As you work you will see there will be a vast difference of outcome according to the tools you choose and the paper you work on.

For this exercise, I suggest that you use the sketch I made initially, and do your own interpretation. You can use any paper and any tools but try to keep it fairly simple. Save your work to the Gallery.

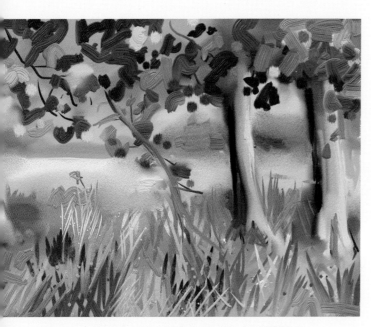

Fig. 5.10 **From the same original sketch by Janet Phillips**

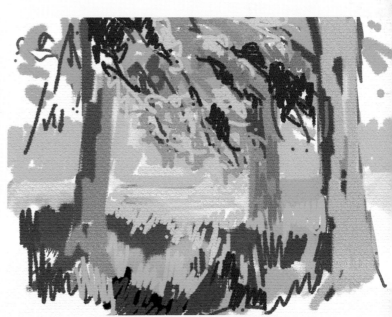

Fig. 5.11 **This is the third version of the same basic sketch.**

This picture was completed in less than 30 minutes from the darkness of a room, looking through a window. The picture is not taken to any finished state, but could be something that I might paint from at a later date. Canvas Basic was chosen as the surface to work on and the paper was coloured blue with the Fill Tool. The cool greens in the background and the billowing clouds were points of interest. The Chalk Tool, with its easy settings, was used for the trees; the clouds were made by the Eraser.

This picture of the orchard at Watcombe was done sitting under the shade of a tree. The fascinating light and shade in this orchard motivated me to sit down and paint from that spot. Canvas Basic was chosen as a surface to work on and the scene was painted directly with the Oil Brush. Preset Normal Round, Size various, Pressure 50%, Thinners 0%, Loading 60%, Insta-Dry on, Auto Clean on, Square Head off.

The result is not entirely successful but I am including it here to encourage you to experiment, even if you make mistakes.

This picture below (Fig. 5.14) was done on a bright sunny day in high summer; I had to sit in the shade of a bush to be able to see the screen. Working from the back of the picture I used mainly the Chalk Tool and softened some of the lines with the Palette Knife. This sketch was used later to make an acrylic painting in the studio.

Fig. 5.12 *Trees at Danesfield House.*

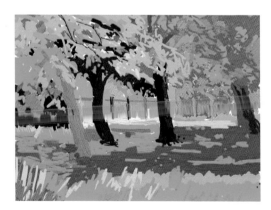

Fig. 5.13 *The Orchard at Watcombe.*

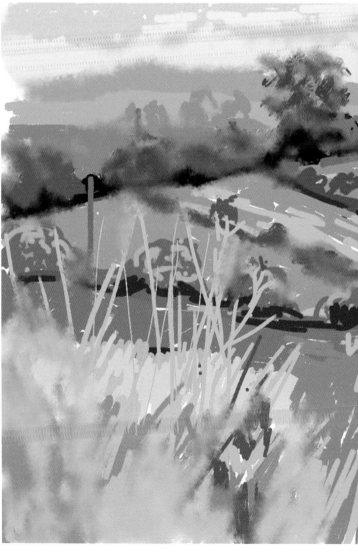

Fig. 5.14 *Summer Landscape at Britwell Salome.*

EXAMPLES OF IMAGINATIVE LANDSCAPES

In the first example by Margaret (Fig. 5.15) the sky was put in with broad sweeps of the Airbrush, as were the distant land and the building and foreground greenery. Detail was then added with the Pencil Tool.

The other example of a rather lovely dreamy landscape (Fig. 5.16), by Janet, draws the eye to the back of the picture and out beyond the fence. It has all the attributes of classical landscape that we mentioned previously and careful colour choices have given the picture a very real harmony.

Fig. 5.15 *Cloudy Landscape* by Margaret Gill. This image by Margaret Gill was made on blue paper. The image was derived from a sketch she had made on paper earlier.

Fig. 5.16 *The View Beyond* by Janet Phillips. We have seen that Hockney's landscapes are not intended to be an accurate description and this image illustrates that with the iPad you can let your imagination wander.

STEP-BY-STEP DEVELOPMENT OF A LANDSCAPE PICTURE: *CORNFIELDS* BY JUDITH FLETCHER

This series of pictures on the following pages charts very closely the development of a landscape which, although it was started *plein air*, was then completed in the studio.

Judith has long been interested in the landscape around her home and has used it frequently in her drawing and painting over many years. This series shows the development from a basic sketch through to a highly refined and studied image, and it may offer inspiration as to how your own pictures might develop. She charts exactly how she arrived at the final image.

Surface: Fine Canvas, Roughness 19%.

Default Size: 1024×768, landscape format.

Colour: I chose bright magenta pink as I wanted this to show throughout the painting and create a rich glow in a colourful autumn landscape.

The picture was completed on a single sheet; I did not use layers.

Pencil Preset: Heavy and Smooth, Size 50%, Pressure 50%, Softness 100%, Smoothing 100%, Precise on.

Eraser Preset: Instant Erase, Size 3%, Pressure 100%, Softness 0%.

Fig. 5.17 First I drew the basic outlines in dark red, based on reference sketches and photos.

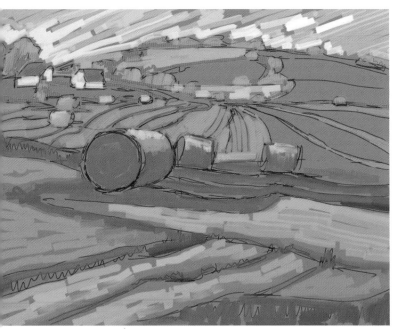 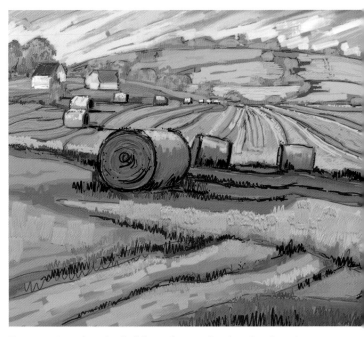

Fig. 5.18 Next I used thin washes to establish the main areas of colour and tone.

Fig. 5.19 I continued to build up colour washes, keeping the paint thin at first, then strengthening the colour towards the foreground and increasing the tonal contrasts.

Oil Brush Preset: Normal Square, Size 25% (also 10%), Pressure 50%, Thinners 75%, Loading 50%, Insta-Dry off, Auto Clean on, Square Head on.

I wanted colours to blend, so I increased the Thinners and turned off Insta-Dry.

For drawing outlines and details I used a Round Brush.

Oil Brush Preset: Normal Round, Size 10% (also 5%), Pressure 50%, Thinners 50%, Loading 50%, Insta-Dry on, Auto Clean on.

Then more drawing; outlines and shadows were strengthened with dark blues.

Oil Brush Preset: Normal Round, Size 4%, Pressure 50%, Thinners 25%, Loading 50%, Insta-Dry on or off to suit the line being drawn, Auto Clean on.

To avoid constantly resetting, I created my own Presets with small sizes of brush for drawing and applying washes.

Next I introduced some texture:

For the trees behind the houses – Preset: Tiny Daubs, Size 20%. I drew over this to refine the shapes.

For the cut corn – Preset: Thick Gloss Square. The solid look of this option suited the subject.

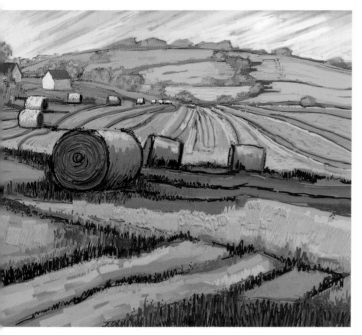

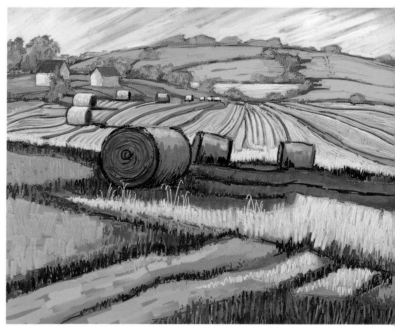

Fig. 5.20 For the sky, I introduced more blue and blended the colours, using Preset: Normal Square as before. I also used the Palette Knife, using Preset: Just Blend Colour.

Fig. 5.21 To complete the final image I lightened the tone of the cut corn to increase contrast, and added details of light in the standing stems against dark shadow to enhance the foreground.

Background: I developed the houses, trees and background fields, using Square and Round Oil Brushes as before.

Foreground: I darkened the shadows with a thin dark blue wash, using increased Thinners and reduced Loading.

I added bulk and colour to the grass areas at the front with thin strokes of reds, greens and blues.

Oil Brush Preset: Normal Round, Size 5%, Pressure 50%, Thinners 25%, Loading 50%, Insta-Dry switched on or off to suit the line, Auto Clean on.

I worked on the texture of the cut corn, introducing thick bold slabs of colour.

Oil Brush Preset: Thick Gloss Square, Size 10%, Pressure 50%, Thinners 0%, Loading 60%, Insta-Dry off.

Then areas were broken down with smaller strokes.

Oil Brush Preset: Thick Gloss, Size 5%, Pressure 50%, Thinners 0%, Loading 60%, Insta-Dry off.

Palette Knife Preset: Hard Out Smudge, Size 10%, 1st type of Smudge, Pressure 100%.

I also used Size 5% for softening hard edges and lines.

Judith has described in great detail how this image was made. At each stage the picture has moved forward, and each aspect of the picture was considered in relation to the others. This is a really important factor when you are trying to make a balanced composition with unified colour and tone.

Landscapes provide us with a never-ending source of inspiration, with their constantly changing light, weather and season, and the iPad is an ideal resource for capturing this subject matter.

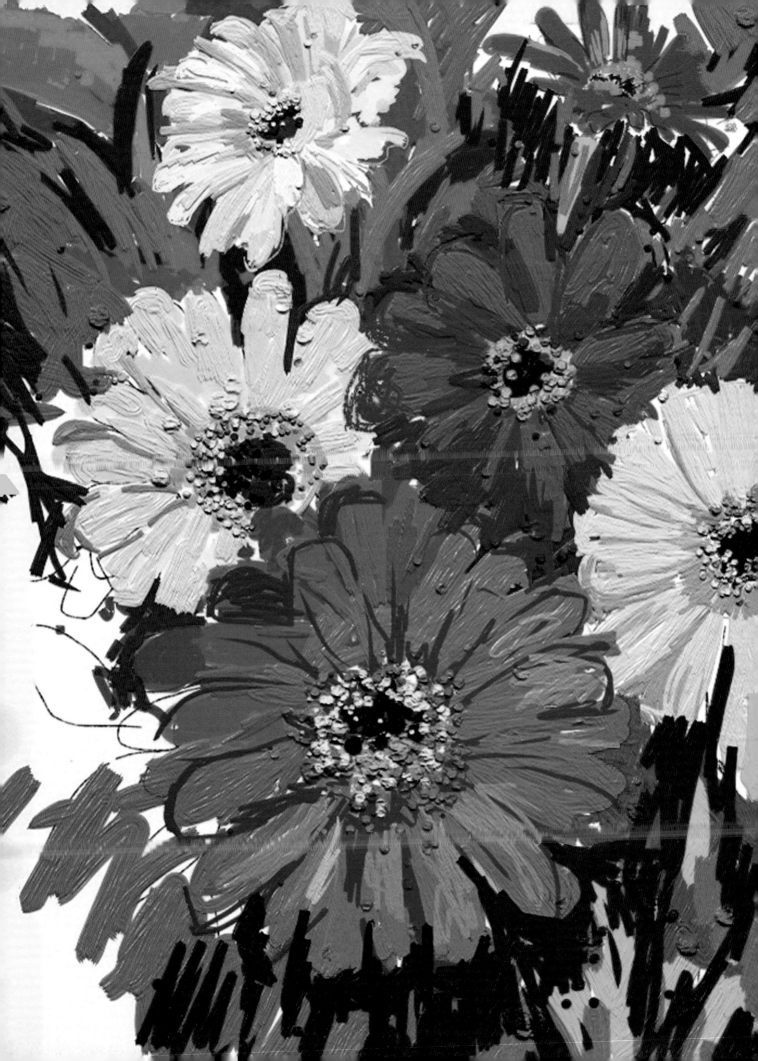

Flowers

I draw flowers every day and I send them to my friends so that they get fresh blooms every morning. And my flowers last.

DAVID HOCKNEY

lowers are a constant source of joy to artists all over the world. Most local supermarkets now have flowers nearly all the year round and so there can be a ready source of inspiration for iPad painting and drawing. The sheer variety of colour, texture, shape and form makes flowers an ideal material for creative people.

I suggest you look again at paintings of flowers by famous artists. They can be very useful for providing inspiration and direction. Think about the Sunflowers of Van Gogh or the erotic flower paintings of Georgia O'Keeffe; these can

provide a starting point for some work. Also you may have a garden that will provide a source of readily available material. Always remember that flowers can fade quickly, especially if it is warm, so do take a photograph with your iPad if you expect to do a picture in a few sessions.

To begin, we will look at some of the tools that lend themselves very readily to the interpretation of flowers. All the exercises in this book are meant to prompt your imagination and creativity; you do not have to follow the suggestions slavishly at all, but just use the ideas demonstrated, changing the colours and type of flowers as you wish.

Fig. 6.0 *The Gift of Gerberas.* The image here was inspired by a bunch of flowers given by a friend. Their vibrant colours encouraged me to paint them. A more detailed explanation of this picture is given in the main text.

Blue flowers

Select Basic White Paper and pinch in. Using the Fill Tool, make a mid-tone piece of paper. To draw the flowers choose a colour that tones in with your ground.

Select Chalk Tool, Size 40%, Pressure 50%.

Make a selection of dark-, medium- and light-coloured marks of different tones, to suggest a bunch of flowers on the paper. Selecting the default settings for the Palette Knife and with the Preset at Hard Out Smear, drag the stylus over the screen to make flower heads, stems and leaves. It is quite fun and highly creative.

Flowers with the Roller and Inking Pen

Select Canvas Basic, for an interesting texture, and pinch in; Roller Tool, Size 50%, Pressure 60%, Thinners 0%, Loading 50%, Auto Clean on.

Make some haphazard marks over the background, leaving some of the white paper showing. You should now have an interesting surface to work on.

Select Inking Pen, Size 10%, Blend Mode normal, Taper Length 15%, Aspect 100%, Rotation zero, Opacity 100%, Smoothing 100%, Square Head on, Antialias Edge on.

Draw some flower shapes freely over your background, altering the size as you go. The flower shapes can be what you have seen or derived from a book. Now add some leaf shapes to your design.

Fig. 6.1 Using the Chalk Tool and the Palette Knife Tool to make some flower shapes.

Fig. 6.2 Flower shapes on a background using the Roller and then drawing with the Inking Pen.

EXERCISE 3
Experimenting with the Fill Tool

Angela made this imaginative illustration (Fig. 6.3). Initially the picture was drawn in a very figurative way with warm red poppies plus leaves and stalks and some bits of hay. This was all drawn with the Wax Crayon Tool on Basic Paper. After the initial drawing the flowers were frosted using the following settings:

Palette Knife Tool Wet, Size 30%, Pressure 70%, Falloff 50%, Drip Size 0%, Drip Spike 0%, Drip Spread 50%, Colour Drag 40%, Preset Small Frost.

Finally, the dark background was added with the Fill Tool, Opacity 100%, but Spread only 10% as there is only a small area being filled.

Now try your own version of this method, using the same paper and tools. The whole process is highly experimental and you will probably find it difficult to reproduce exactly the picture in the illustration; however, it introduces you to some highly exciting processes. Do be free and creative.

Fig. 6.3 *Poppies in the Wheat* by Angela Whitehead. Working with the Palette Knife over existing images.

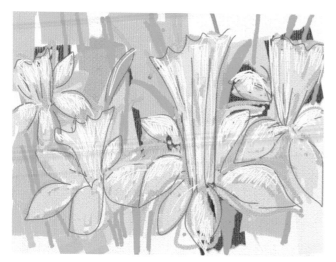

Fig. 6.4 *Invite to the Easter Party.*

Fig. 6.5 *Daffodils* with the Wax Crayon.

Fig. 6.6 *Daffodils* with the Airbrush.

Examples of flower pictures showing different ways of using a single image

It can be fun to take just one flower and see what the iPad can do with it.

This series of pictures was made from looking at a simple daffodil and then experimenting with a large variety of tools using the basic flower shape. If possible use a real flower to work from as it gives you greater awareness of tone, shape, and colour.

The first picture (Fig 6.4) was started on White Canvas Grain Paper and leaf marks were made on the paper with the Chalk and Airbrush tools. Over this, the rough shapes of the daffodils were put in using Wax Crayon with different tones to represent the form of the daffodils, and some dot marks were added for the stamens. Finally the Pencil was used to add definition. The whole picture is quite rough and ready and was intended for use as an invitation to an Easter party.

The next image was made using White Basic Canvas Grain paper again (Fig. 6.5). This picture draws on much the same set of tools but they produce a more figurative effect. The composition has cohesion because the colours are limited. (This point is worth noting in all your work, as using too many different colours fragments the overall design.)

After some free use of the Roller Tool, the daffodils were drawn with Wax Crayon and the highlights put back in white. Stems were added with Wax Crayon and again there was some final drawing with the Pencil Tool.

In the final picture (Fig. 6.6) the Airbrush Tool was used here, to give a 3D effect. The Airbrush settings for the background were Size 50%, Blend Mode normal, Pressure 80%, Tilt Angle 100%, Taper Length 100%, Opacity 100%, Autoflow off.

The foreground daffodils were then made with a smaller brush. The Pencil Tool was in evidence again, to add a little bit of detail.

Using the Palette Knife to enhance and transform an image

To start this picture (Fig. 6.7) Angela selected White Paper Basic and using the Airbrush Tool shaded a fairly light colour for the background. The Crayon Tool at 20% Opacity was used to make some leaves; they were quite rough because she was going to smudge them out with the Palette Knife later. Some white flower shapes were drawn in next with the Crayon Tool, Size 10%, Pressure 50%, Softness 50%.

The flowers you see in the illustration were derived from white Japanese anemones, with a bit of artistic licence. A darker brownish centre was added to the middle of each main flower. The screen was pinched to give a higher resolution and stamens were added with Yellow-brown Pencil, Size 50%, Pressure 50%, Softness 100%, Tilt Angle 0%, Precise on.

Next with the Palette Knife on default setting she altered the size to just 30% and moved the Preset to Frosted Spots and smudged the area of the greenery. Some edges of the flowers were also merged into the background. With a dark Pencil some of the edges of the flowers were crisped up and some shading was added on the petals.

Angela decided she liked this picture, but wanted to experiment further with the image. She therefore saved her picture into the Gallery and then continued to work on the image.

The second illustration (Fig. 6.8) shows the same picture after it has been manipulated using the Palette Knife using Hard Out Smear and Frosted Spots, dragging the existing paint (as in the very first exercise, page 64).

Fig. 6.7 *Garden Flowers – 1* by Angela Whitehead. Angela made this picture from flowers she had in her garden.

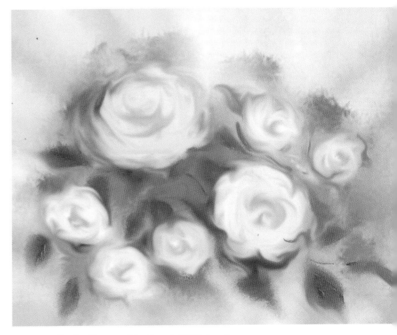

Fig. 6.8 *Garden flowers – 2* by Angela Whitehead.

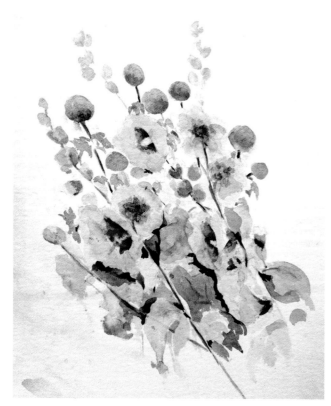

Fig. 6.9 *Hollyhocks in Watercolour* by Angela Whitehead. This gentle watercolour painting by Angela was inspired by seeing a plethora of hollyhocks in a garden.

Fig. 6.10 Initially a green paper was made by using the colour selector on the start-up screen. The Chalk Tool was used for the basic shapes.

Fig. 6.11 Further basic shapes were added with the same settings and the Chalk Tool.

Transcribing from an existing flower painting

Choose a flower painting by an old master or, even better like Angela, use one of your own paintings. To be able to understand and appreciate the textures, colours and shapes of the original vision. The composition is already worked out and there are some clear guidelines to follow for the colour and tone.

Shown above is a picture done with real paint and paper. Encouraged by the shapes and colours of the flowers on a very sunny day in July, Angela produced this watercolour painting. It was roughly A3 size and took about an hour and a half to complete. The subsequent picture on the iPad probably took about the same time.

The following series of pictures charts very clearly the progress of the iPad picture. From Angela's original watercolour, you can see her delicate approach coming through on the iPad. The finished picture relies on tiny changes of size and pressure to achieve the subtle changes of tone. This very painstaking approach may not be for everyone but it illustrates well what can be achieved on the iPad.

This picture was made on coloured paper. The description of how to do this was given on page 28, but is repeated here for your convenience. On the initial screen you will find at the bottom of the screen, there is a square which is marked Colour. Select this and you will get a circle containing a square. The outer ring indicates the basic choice of colour and the inner square represents the range of tonal value. Move the outer marker to the colour you want and then move this new tiny circle within the square to the tone you wish. Then just tap the screen in the top left-hand corner where it says Done. If you make the coloured paper in this way, when you rub out it will not go white but return to your original selection.

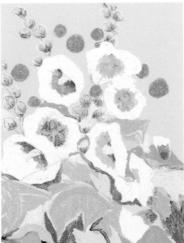

Fig. 6.12 Leaves and further growth structures were added.

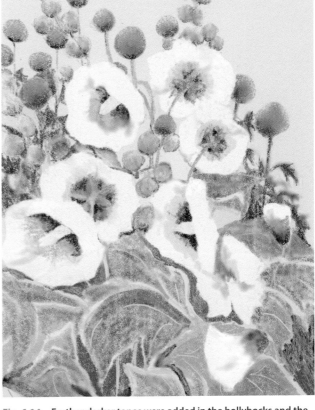

Fig. 6.14 Further darker tones were added in the hollyhocks and the echinops.

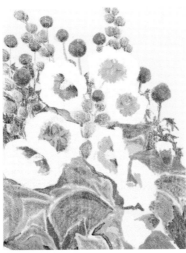

Fig. 6.13 Further drawing into the shapes. Darker tones were added to suggest the form of the leaves and the blue flowers of the echinops.

For this picture after choosing the tone of the paper and looking closely at the original watercolour the basic shapes were drawn with White Chalk, Size 15%, Pressure 12%.

When finer detail was needed, Size went down to 3%, Pressure 9%.

Gradually more detail was added with the Chalk and the screen was pinched to enlarge the image, enabling the details to be drawn more exactly.

These changes were very gentle and subtle, and involved moving the size and pressure frequently. Angela decided, looking at Picture 5, that the Echinops were rather too dominant in the picture and decided to use the Palette Knife Tool to soften the edges. Selecting the Palette Knife (Size 25%, Pressure 40%, Preset Instant Blur), she softened some of the edges in the picture. At this point she also decided that

the background green colour was too dominant and that something warmer and gentler should be chosen. Various colours were experimented with by changing them with the Fill Tool. Settings of Opacity on the Fill Tool were 25% and the spread of 10% was chosen. Don't forget you can use the Undo button of the iPad if you feel you have chosen the wrong colour. Where there were gaps between the flowers, the background spaces were filled individually. If you find when using the Fill Tool it fills too much of your drawing, check the Spread setting. In Angela's picture the Fill Tool has actually infiltrated some of the flowers, but this accidental effect is rather pleasing.

This sequence, with all its stages, may encourage you to experiment with working on a coloured background, using the Chalk Tool in a small size, practising making colour changes to suggest the form, and blurring edges with the Palette Knife.

Fig. 6.15 *Japanese Anemones*. An example of a highly detailed picture by Angela Whitehead.

Various flower images

The flowers displayed in the following illustrations are included to inspire your own work. The artists share their techniques so you can understand and appreciate their approach.

This lovely picture of Japanese anemones was done by Angela. Her delicate touch is obvious here again. She chose a dark green paper to highlight the softness of the flowers. The dark green paper was achieved by first selecting Paper Basic and then making the green colour from the original start-up screen. The Chalk Tool was chosen with colour white, Size 40%, Pressure just 10%.

Gentle pressure given a wonderful three-dimensional effect for the petals in this situation and the tool behaves very much like Chalk on a coloured surface in real life. After the petals were drawn, the Palette Knife tool was selected, Size 10%, Pressure 15%. Preset Instant Blur was used to smooth the tones together.

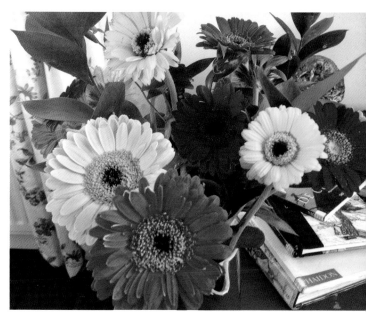

Fig. 6.16 The photo was landscape in format, but I decided a portrait composition would be more fitting.

After that some pure white highlights were added with the size very small to accentuate the shapes of the petals. The light green centres were drawn, then gentle layers of colour on low pressure to give added form. Stamens were put in with the Pencil Tool (Size just 8%) on an enlarged screen with some subsequent slight blurring with the Palette Knife. Stems were drawn in with the Chalk Tool on low Pressure, but subsequently overlaid with other colours on low Pressure to build up a subtle effect.

GERBERAS

Before embarking on an iPad picture of these wonderful gerberas above (Fig. 6.16) I took a photo of them in case their vibrant colours should fade before I had finished.

Wanting so much to capture their fabulous colours I started by drawing them directly using the Pencil tool. When I was happy with the composition, I decided that the Oil Brush was the most appropriate tool to capture their strength of colour and started to paint into the drawing. Layers were not used. Starting with the Small Round Oil Brush, the flowers were gradually filled in. The Oil Brush was on Insta-Dry setting, as I did not want the colours to smear. When something was wrong and the paint became too thick I rubbed back to the white paper with the Eraser.

Fig. 6.17 As I worked, I tried to think of the tonal pattern over the picture surface and consequently filled in the green areas more solidly to accent the flower shapes.

The Oil Brush was very effective in making the centres of the gerberas as the paint went on in small blobs. Nearing the end of the composition, I decided I really liked some of the white paper showing on the edges and decided not to fill it in. The white made the picture more lively. Finally I was pleased with the outcome and felt that I had indeed captured the rich colours. The finished picture is shown at the front of this chapter.

Fig. 6.18 *Sunflowers* by Janet Phillips. This picture is an example of a complete painting, with its focus of flowers.

STILL LIFE WITH FLOWERS

This picture displays excellent composition and colour harmony. Janet used layers to make this picture (*see* Chapter 10).

Janet writes about creating this image:

> To start with I chose a smooth paper and selected a blue background so that the yellow would stand out. There were three different layers in the picture: one for the sunflowers on the top, one for the vase underneath and the bottom one for the background at the end.
>
> For the sunflowers, the vase and sunflower centres, I used the Chalk with maximum Pressure. With the Oil Brush on the Everlasting Oil Preset, the petals and the leaves were painted. To get the pointy ends I then used the Palette Knife with Hard Out Smear Preset; the background was painted using the Roller and the Palette Knife with Hard Out Smear and also Harsh Chaos Presets. The top right blue shapes were pulled out with the Hard Out Smear Palette Knife.

Fig. 6.19　*Aster* by Angela Whitehead.

Fig. 6.21　*Peony* by Mary Langham.

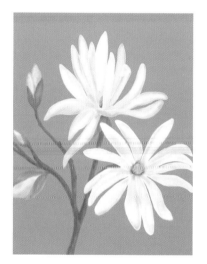

Fig. 6.20　*Magnolia* by Angela Whitehead.

A SELECTION OF IMAGES TO DEMONSTRATE THE IPAD'S VERSATILITY

This very delicate drawing of an Aster was made by Angela. She used Soft Tipped Pencil throughout. To begin with the Pressure was very low and she drew only the petal outlines, the leaves, and the stalks. After that she began to add some shading. Next she drew the yellow marks in the centre, in two different colours, and then carried on to put some dark in the centre of the flower and darkened the leaves with green.

The Magnolia is another of Angela's delicate drawings. She made a blue background on the initial screen. A real magnolia in her garden provided the image for this picture. The petals were drawn in with a white Airbrush as block shapes; no outline at this stage. Gradually the different shades of the petals were built up by altering the pressure of the Airbrush

and some touches of very pale pink were added on very low pressure.

The centres of the flower were made with some very small Chalk marks and the Eraser was used to neaten the shapes. Chalk was employed to draw the stems with browns and sludgy greens and the Palette Knife was used to blend the colours together. Buds were then added with the same tools. Finally, using a very small setting, the petals were edged with Chalk and the Eraser to neaten any hairy edges.

This first image by Mary was done in much the same way as the previous one. The thick oil paint interprets well the rich, blousy nature of a peony. She did this from a photo taken in my garden; the fact that she took the photo herself really helped her when she came to use the iPad. Printing an image from her photo she made the picture by first painting directly

Fig. 6.22 *Orchid* by Mary Langham.

Fig. 6.23 *Fuchsia* by Janet Phillips.

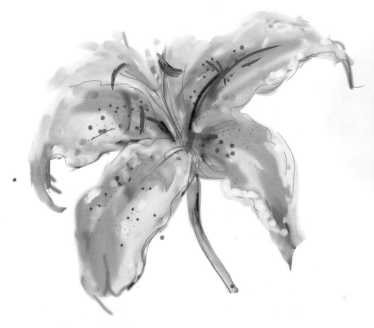

Fig. 6.24 *Lily* by Wendy Robinson.

with the Oil Brush and then using the Palette Knife on Hard Out Smear to make the texture of the petals. The composition of this picture is daring and very exciting.

The Orchid above by Mary was done by drawing directly from an orchid flower with a second flower placed behind it, as she felt it made a more interesting composition. First she made a piece of green paper with the Fill Tool and then sketched the outline of the flowers with a small setting of the Oil Brush. Petals of the flowers were then painted thickly with the Oil Brush on a slightly larger setting. The paint was then smeared and pushed around with the Palette Knife until the required texture on the petals was reached. Centres of the flower were added with the Chalk Tool.

This lovely interpretation of a fuchsia was created by Janet. Against a background produced with the Roller she has drawn the flower directly, observing very carefully the changes of tone, which gives a wonderful form to the bloom. She painted the petals with the Watercolour Brush and used the Inking Pen at the end to do the stamens.

The final image here is of a lily by Wendy, she writes about the making of the picture.

The lily came from my imagination through studying flowers for years and homing in on their beauty. My iPad was new and I played with the tools to achieve the image and construct the shapes I wanted. Mainly using the Watercolour Brush I played with the size, pressure and Heavy Bleed, which gave a softness to the edges of the petals. The stem was also painted with the Watercolour Brush. The stamens were put in with the Inking Pen in the Round and Smooth Mode and with Taper Length at 40%. The spots were made with the Marker Pen in various sizes, full Softness and 50% Wetness. To finish it off, I used the Pencil to pick out the petals, attach the stamens and edge the stem.

Chapter 7

Portraits

Faces are the most interesting things we see; other people fascinate me and the most interesting aspect of other people – the point where we go inside them – is the face. It tells all.

DAVID HOCKNEY

David Hockney has been fascinated by portraiture for many years now. Indeed, in the book that accompanied his 2012 exhibition, entitled *David Hockney: A Bigger Exhibition* there is a chapter entitled, 'Exploring the landscape of the face'. Even before he drew anything on the iPad he was fascinated by the subject of portraiture. A series of very sensitive line drawings, of intimate friends in the 1970s, showcases his superb drawing skills. Quite small in size, these pictures show his amazing ability to capture a likeness in pure line. It is no real surprise then, that this skill has been transferred into drawing self-portraits on the iPad. On pages 164–5 of the Hockney book there are eight very perceptive self-portraits done on the iPad, showing Hockney with a wide range of expressions. Some pictures are more carefully worked; others are more fleeting; however, all are full of insight and careful observation. In these portraits Hockney has not attempted super-realism, but within each portrait there is an insight and honesty.

Of all the various types of subject, portraiture is probably the most difficult. When copying a picture from a newspaper or trying to draw a friend there is a need to get it right. Eyes, nose, mouth, etc. all have to be in the right place to get a likeness. With landscape or flowers, for example, some artistic licence can be allowed and it usually does not matter if you are not absolutely exact.

Another difficulty with portraiture is access to the subject matter, which is often rather difficult. Do you ask someone to sit for you? Do you copy from a magazine or do you try to do a self-portrait? Rembrandt created nearly a hundred self-portraits in his life time and I suspect he was aware of the fact that he had a readily available, cheap model. It is interesting that he sought to change his appearance somewhat with different clothes and hats.

Fig. 7.0 *Samburu Teenager from Kenya* by Judith Fletcher. The bright colours in this picture attracted Judith initially and she decided she would like to copy it as an iPad exercise. After some drawing with the Pencil she used a variety of tools to complete the picture.

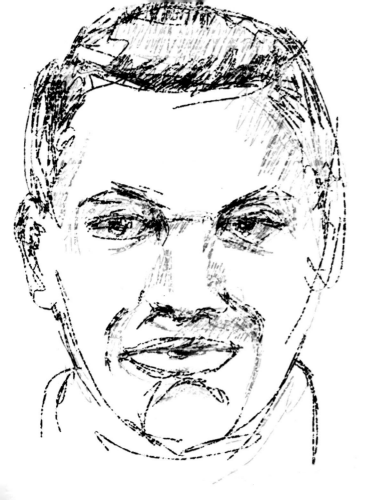

Fig. 7.1 **Here is an example of how your finished picture might look.**

Copying a simple head from the newspaper

We all have to start somewhere and I suggest that you look at a newspaper or magazine for inspiration. There is a wide range of images to chose from, but beware that very beautiful girls with no lines on their faces are notoriously difficult. It is better to choose a face that is full of character.

Selecting just the Pencil Tool, copy a head. This was described before (*see* Chapter 2) but you may have a little more confidence with the stylus now and it would be interesting to compare results.

Choose White Paper Basic, Pencil Tool, Size 100%, Pressure 100%, Softness 30%, Tilt Angle 0%, Precise off.

Sketch out the head. Remember the Eraser and the Undo button. Once the main lines are drawn, changing the colour from black to grey will produce a more subtle effect.

The simple line drawing below was done on black paper with the Chalk Tool set on white, with a small size but maximum pressure. This sketch was done from life, hence the sketchiness in execution The other small sketch – again from life, in an airport lounge – was done with Pencil and Watercolour.

Fig. 7.2 **Try to do a few drawings of heads in different media, in different kinds of positions. Use a variety of tools. Here are two examples that might inspire you.**

EXERCISE 2
Animal portrait using the pencil to imitate fur

I suggest that you try to draw an animal using your own photograph, with the same tools as Angela used in her cat picture (Fig. 7.3).

For this picture Basic Paper was selected and the grey colour of the paper was made with the Fill Tool.

Select the Pencil Tool, Preset Soft Tip, Size 100%, Pressure 16%, Softness 100%, Tilt Angle 45%, Precise off, colour brown.

Initially the body and the face were drawn. Marks with the pencil were made in the direction in which the fur was growing. The whiskers were added at the end, over the top of the fur. White whiskers made with the eraser were too strong so the base colour of the paper was picked up with the Colour Sampling Tool; then with the Pencil on a very small size, the whiskers were added.

EXERCISE 3
Eraser portrait – rubbing away the surface to make tones of white

Doing a portrait like this gives you excellent practice at looking at the subtle changes of tone in the face. This exercise will also enable you to become more familiar with the Eraser Tool. This picture was selected from a newspaper because it had many tonal changes.

Basic Paper was selected and coloured blue with the Fill tool. The main shapes of the head were drawn with the Eraser, Preset Hard Edged. The size and pressure of the Eraser were varied throughout the drawing. Finally the Palette Knife was used to soften some of the edges.

Select a picture from a newspaper or magazine that shows tonal variety in the face and try making your own portrait with the Eraser. This is not an easy exercise and you will need lots of practice; however, just looking at the variety of tones will certainly sharpen your visual senses.

Fig. 7.3 *Next Door Cat* by **Angela Whitehead.**

Fig. 7.4 *Tonal Head* by **Janet Phillips.**

This pencil portrait, from a picture in a magazine, was gradually built up as described below.

Basic White Paper, Pencil Tool, Preset Soft Tip. Initially all the default settings were used.

Firstly the outline of the face was drawn very faintly using a grey colour. All the features were gently placed within the face. Where the picture in the newspaper was dark the size and pressure of the Pencil were increased to get really dark tones. The heavy shading was gone over many times, especially in the hair so that the lighter strokes could be placed on top. The eyes were developed next, still with the Soft Tip pencil, all the details of the eyes being done on an enlarged screen with small marks. There was also some Palette Knife blending in the eye itself.

The nose was drawn on very low pressure and small size. The lips were drawn in the same way but the pencil marks were too obvious and had to have some Palette Knife blending (using Soft Blur, on very small size and low pressure) to make them appear smooth. As with the eye this work was done on an enlarged screen. The hair was rather a labour of love: lots and lots of individually drawn pencil lines with many differing pressures, needing much patience to build up the real texture of the hair. Highlights were put back into the hair with the Eraser, Preset Soft Eraser, on a very small size, in fact used as if it was a white pencil. Finally some fine pale shading was put on the face and some of these lines were blurred with the Palette Knife.

There was a tremendous amount of trial and error and the Undo button was used frequently when the setting was wrong; needless to say this drawing took several hours to complete.

Fig. 7.5 Pencil portrait by Angela Whitehead. This studied pencil drawing may strike terror in your hearts and make you think that you will never achieve anything like this. However, I have included it here to show what can be achieved with lots of practice and lots of patience.

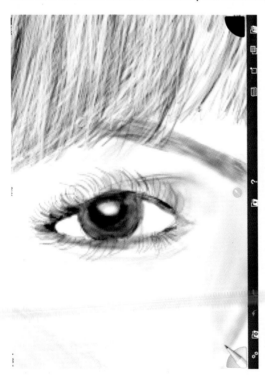

Fig. 7.6 Illustration showing an enlarged screen.

EXERCISE 4
Portrait using the Oil Brush

Select a picture from a magazine that is not too complicated and one you think you would be able to paint. Choose Canvas Basic to work on.

Janet initially drew in the outline of the head with the Oil Brush on the Preset Normal Round on a small size and then went on to build up the colour gradually, working on an enlarged screen to put in the finer details.

Now choosing the same surface, the same tools and the same method, attempt your own Oil Brush portrait. Do not be dispirited if you are disappointed with the result; you will have learnt so much just by trying.

PORTRAIT OF BUFFIE BY ANGELA WHITEHEAD

Not all portraits have to be human. Pet portraits have become increasingly popular recently, as owners welcome a special picture of their treasured pet.

This series of pictures shows how Angela portrayed her dog with the iPad and it is useful to see how the image was built up.

It is standard practice with animal portraits for the artist to work from photographs. Animals will just not keep still long enough.

The two settings of the Chalk Tool, Size and Pressure, were varied constantly. Colour changes were painstakingly moderated to make the subtle changes to represent the fur. Marks made by the Chalk Tool were blended using the Palette Knife Tool.

Fig. 7.7 *Young Girl* by Janet Phillips. The example shown here provides a rough guide as to how your portrait copy with the Oil Brush might look.

Fig. 7.8 Angela chose White Basic Paper and, working directly from the photograph, the basic shape of the dog was drawn in with the Chalk Tool.

Fig. 7.9 The image was further defined with some careful drawing, and darker tones were added. The eye was drawn in greater detail on an enlarged screen, as was the collar.

Fig. 7.10 Angela decided that the white background was too stark and changed it to light blue with the Fill Tool. Further detail was added to the fur and the nose was drawn in more carefully. Buffie even had some eyelashes added with the Pencil Tool at the end, on an enlarged screen.

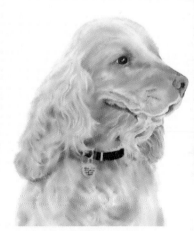

Fig. 7.11 These pictures illustrate well how the final image was built up.

Various portrait images showing different approaches

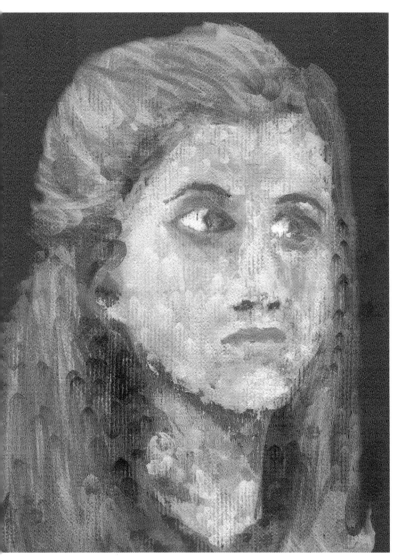

Fig. 7.12 **First iPad portrait with the Oil Brush by Mary Langham.**

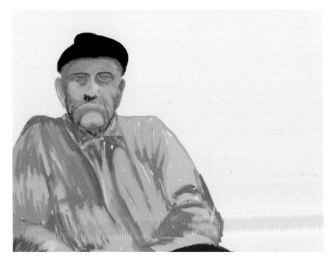

Fig. 7.13 *The French Peasant* by Elaine Fear. Elaine did this gentle portrait, sketched from a photograph, showing a similar painterly approach to the subject matter.

Mary chose Basic Canvas and with the ground still white, the image was imported through the tracing layer and the outline was sketched in with a grey Pencil Tool. After deleting the original image the face was painted using the Oil Brush tool, Preset Tiny Daubs with default settings in place. The size was altered frequently. Preset Thin and Dry was used for the hair. Colours were carefully moderated to make the tones in the face; the Undo button was often used. The white background looked rather stark and the Fill Tool was used to change the colour. The blue background was rather harsh in places and some more hair was added to go over the blue to make it look more realistic. Mary said she was often in despair when doing this picture but she was pleased in the end with her first iPad portrait.

The image below by Elaine (Fig. 7.13) was taken from a photograph in a magazine. The surface was Paper Basic and initially the grey background colour was made with the Fill Tool. Then the outline of the head and the hat were sketched in with the Inking Pen. Subsequently the head was enlarged to 400% to draw in the details on the face, still using the Inking Pen with the Opacity reduced; this allowed Elaine to create the subtle skin tones of the grey hair and the beard. The Airbrush was then used to smooth out some of the highlighted areas, with Opacity reduced, picking up the colours from the face. A combination of Inking Pen and Crayon were used for the shirt and the Palette Knife was used to blend some of the shading.

A SERIES OF PICTURES BY JUDITH FLETCHER SHOWING THE DEVELOPMENT OF A COMPLEX PORTRAIT

This set of pictures shows a very different way of working. Judith initially drew the figure from life but it proved difficult for the sitter to hold the pose so a photograph was taken, and the iPad picture progressed from the photo print.

The surface chosen was Basic Canvas with 25% roughness selected on the original 'set-up' screen. Square format was chosen (1000×1000) and a pale blue colour because it would work well with the shape of the pose and the warm colours of the subject. It is necessary to make such decisions carefully before embarking on a piece of work that is inevitably going to take a long time.

Fig. 7.14 Initially the overall composition was sketched and colour areas mapped in.

Fig. 7.15 Next the details of the hands and face were worked on, still with the same settings and the Round Brush. Some corrections were made using the Eraser.

Fig. 7.16 This next picture shows a gradual build up of colour, with thought given to emphasizing the light and dark areas.

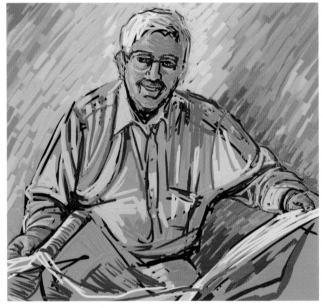

Fig. 7.17 Work was continued on the picture with both Round and Square Brushes.

Fig. 7.14: Oil Brush, Preset Normal Round, Size up to 10%, Pressure 50%, Thinners 25%, Loading 50%, Insta-Dry and Auto Clean on.

Fig. 7.15: Preset Instant Erase, Size 2%, Pressure 100%, Softness 0%.

Fig. 7.16: Oil Brush, Normal Square, Size from 10%, Pressure 50%, Thinners 25%, Loading 50%, Insta-Dry on (as crisp lines were still needed), Auto Clean and Square Head on.

Fig. 7.17: The Round Brush was used to fine tune the outlines, using sizes from 4%–10% with Insta-Dry on. The Square Brush was used to build up colour, sometimes omitting Insta-Dry so that the colours could be blended. Occasionally the Palette Knife was used to soften edges and aid blending of the colours, Preset Hard Out Smear.

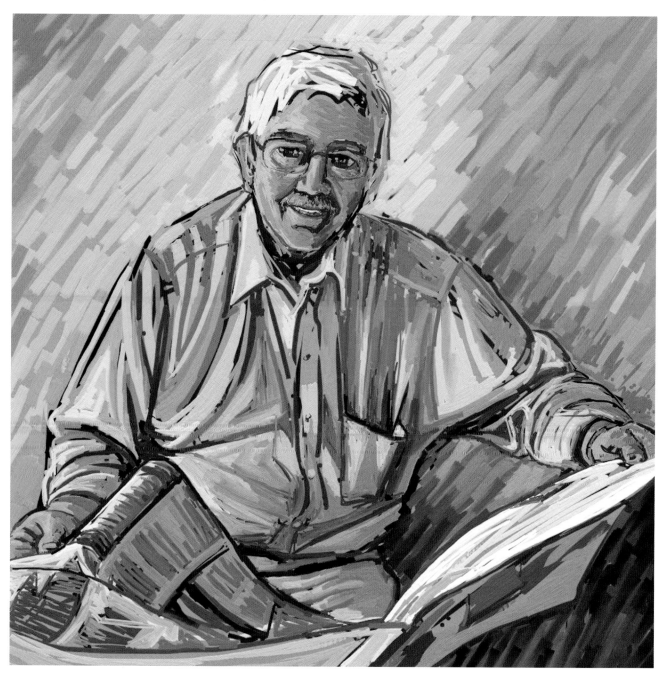

Fig. 7.18 **Next fine detail in the face was worked on, aiming to get the likeness of the sitter.**

Fig. 7.18: Judith expanded the screen to work on the detail using both Normal Round Brush, Size 4%, Insta-Dry on, and Normal Square Brush, Size 10%, Insta-Dry off.

This succession of pictures shows very clearly how Judith built up the image. The composition and use of colour within the picture are both excellent, and it is interesting to see how the base colour of the paper has been allowed to show through, giving unity to the composition. Also note how

lines within the picture have followed the direction of the surface they represent. Judith's husband Dick was pleased with the result.

I mentioned the need to use photographs when drawing or painting a portrait, but this does not mean you cannot use some imagination and inventiveness when copying. Angela did this fun portrait of the Queen (Fig. 7.19), who is instantly recognizable, showing a very creative approach to the various tools that the iPad has to offer.

Fig. 7.19 A very patriotic image of the Queen by Angela Whitehead.

Fig. 7.20 *Samburu Teenager* by Judith Fletcher. The attractive portrait you saw right at the beginning of this chapter was taken from a magazine picture of a Samburu teenager from Kenya. Judith copied this picture and was attracted to it initially by the bright colours.

This portrait was done on Paper Basic, making the red colour on the initial screen. Angela decided that she wanted to use patriotic colours. The blue outline of the hat and the body were done with the Chalk Tool working with different sizes. Flesh colour was chosen and the face filled in, allowing parts of the background colour to show through. The face was deliberately not blended too much. The hair was carefully added and softened with the Palette Knife and the harsh blue lines of the eyebrows were softened. Some of the main blue lines were tapered at the ends or straightened with the Eraser.

It was an enormous help to be able to expand the size of the screen when it came to doing the detail on the face. The pearls were also drawn on an expanded screen. This is a really important facility for portrait drawing and painting. The hat decoration was made with blue and white stripes, leaving some of the red showing through. These lines were smoothed with the Palette Knife on Preset Hard Out Smear.

This example shows how it is possible to be imaginative with an image and use some exciting colours in the face. Do look at the marvellous painted portrait of the artist Matisse by Derain, a portrait that was made during a holiday at the fishing port of Collioure in the south of France in 1905. (This image is readily accessed on the Internet.) By looking at this example you will see that Derain has kept to the basic structure of the head but used the most unusual colours.

PORTRAIT BY JUDITH FLETCHER

For this portrait the surface was Basic Canvas with a rough texture added on the initial screen. The colour remained white.

First the main shapes were sketched in with the Pencil Tool, Preset Soft Tip, Size about 30%. Some of the texture of this initial surface is still visible in the necklace but elsewhere a smoother finish was employed. Next, key details of the face and jewellery were drawn with the Inking Pen, Preset Inking Pen. The size varied but was usually below 5%. For building up colour, the Felt Pen was used, Presets Blending Markers, Hard Tip and Soft Markers, Sizes up to 30%. Roller Preset Thick and Smooth, Sizes up to 20%, were also used. For blending the Roller work, the Palette Knife, Preset Hard Out Smear or Just Blend Colour, proved useful, on small size settings. For the final details Inking Pen was used, Preset Inking Pen, with various colours including white. In addition, corrections were made using the Eraser, Preset Instant Erase, on a small size. The screen was expanded to put in the most intricate details.

This chapter has covered what is undoubtedly one of the hardest subjects for the iPad artist, but although it is usually necessary to work from an existing image, it provides a rich source of interest and investigation. The Heads Project in the final chapter of the book will enlarge the possibilities even further.

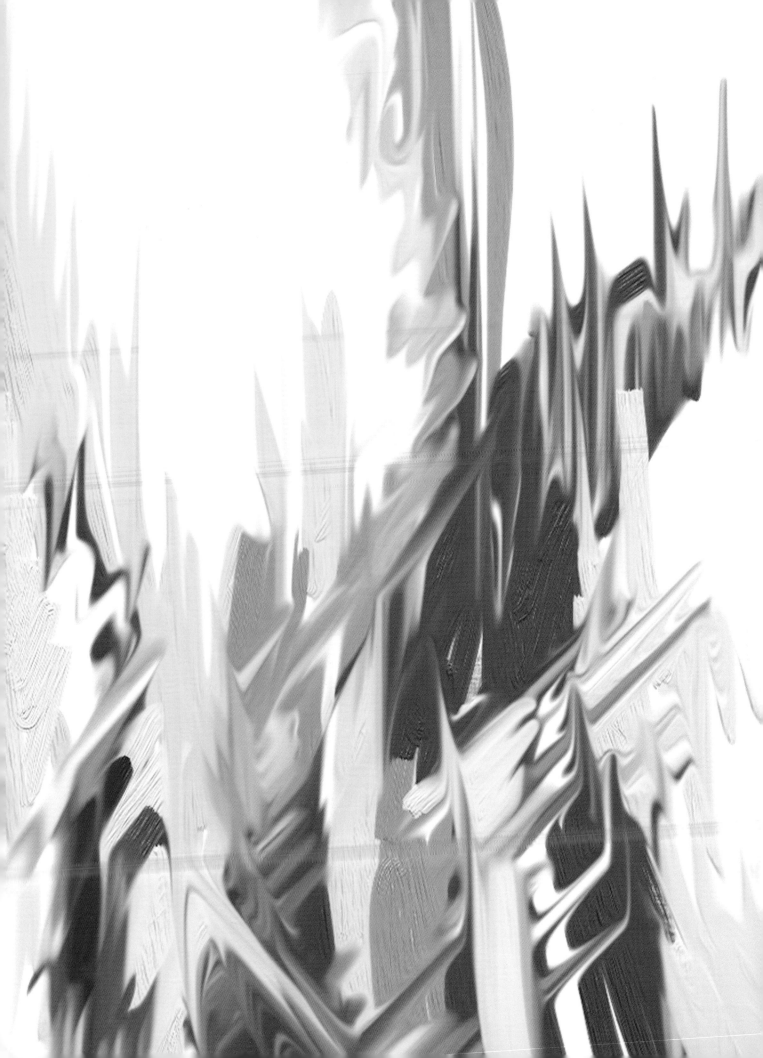

Abstract

You must plan to be spontaneous.

DAVID HOCKNEY

bstract art gives perhaps the greatest range of possibilities for really exciting iPad work. Unbounded by the need to 'get it right', it is possible to give the imagination free rein to enjoy all the tools and their tremendous variety. Look at work by recognized abstract artists (Picasso, for example) to give you inspiration as to where you might begin.

The word 'abstract' can be confusing, as it often brings to mind pictures with marks placed over the surface in a random way as though the artist had just slapped them down without thought. This is rarely true. These marks have usually been placed in a very careful way, chosen by the artist who has made an aesthetic judgement with regard to colour, shape, and composition. Sometimes it is very hard to 'understand' abstract art, as the prevailing westernized attitude expects art to be representational.

This series of exercises is designed to get you thinking in an abstract way.

Fig. 8.0 **This abstract picture was made with the Tube and Palette Knife tools. It was about rejoicing in the marks that the iPad can make. The arrangement of the marks is crucial to the composition and harmony of the picture as a whole. They may appear very haphazard but underlying them is a deep awareness of balance and harmony. It is much harder than you think to make a good abstract, but hopefully by reading this chapter you might enjoy the process.**

Fig. 8.1 First abstract marks.

Fig. 8.2 Filling in the negative spaces.

EXERCISE 1
Changing the way you think and see

Select Paper Basic. Pinch in, Select Roller Tool, Preset Thick and Smooth. Alter the default setting to Size 50%, Pressure 0%, Thinners 0%, Loading 100%, Auto Clean on. Choose a strong primary colour.

Now make some strong, straight lines over the picture surface, keeping in mind the way in which the lines divide the surface of the paper and the white spaces that are left. Make sure that the majority of the lines touch the edge of the paper, or at least almost touch. The spaces (known as negative shapes) should form an important and integral part of your composition. Look at the work of Franz Kline (1910–62), an abstract expressionist artist.

Next choose the Fill Tool, Blend Mode Normal, Spread 10%, Antialias Edge off, Single Layer off. Choose colour green (complementary colour to red). Tap the white areas you would like to fill in with green.

Remove the Tool Pod and Colour Pod from the screen so that you can see the relationships of the whole design. You can really play around with the balance of the spaces so easily.

Do this exercise again, choosing different colours and different shapes.

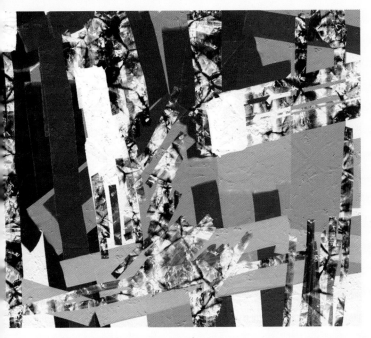

Fig. 8.3 An abstract on textured paper.

Fig. 8.4 Twirling airbrush shapes.

Using negative shape and combining it with texture

Select Paper Concrete, Roller Tool, Preset Thick and Smooth. Change the default setting to Size 40%, Pressure 25%, Thinners 0%, Loading 50%, Auto Clean on. Choose any colour you wish (I chose purple); whichever colour you select, make different tones of that colour. Make marks over the surface of the paper leaving some white paper showing.

Now change the Preset of the Roller to Speckled Line. Choose a dark colour and go over parts of your picture. Due to the nature of the paper it will pick up the surface texture and form an interesting contrast to the solid shapes in the picture. Appraising my picture, I thought it was too busy and so put some solid white shapes back in, with the Roller on Preset Thick and Smooth.

Using the Airbrush with negative shapes

Still working quite simply, here is another exercise based on negative shapes, this time using the Airbrush Tool.

Select Paper Lumpy, Airbrush Tool, Size 85%, and all other settings 100%. Blend Mode Normal, Autoflow on. Remove the Colour Pod and Tool Pod as you work so that you can see the whole screen.

Choose a mid-tone colour and just let your stylus flow easily over the screen surface, changing the tone of the colour as you go along. Make bigger and smaller shapes until you are happy with the result.

With exactly the same settings choose a white colour and go over the picture again, blanking out some of the areas you have already coloured. The effect is rather pleasing. Try to think about the relationship of the marks to each other.

The marks made so far have been quite cool and clinical; now we can go on and make some more expressive marks. The best tool for this is the Oil Brush.

Fig. 8.5　An abstract
picture with the oil brush.

EXERCISE 4
Expressive marks with the Oil Brush

Choose Paper Hatched, and pinch in. Select Oil Brush, Size 45%, Pressure 50%, Thinners 0%, Loading 60%, Insta-Dry off, Auto Clean on, Square Head off, Preset Thick Gloss. Choose a dark colour to begin with and make marks over the surface, keeping in mind the aspects described in other exercises from this chapter, for example how the main lines divide the surface of the paper, and how every shape plays an integral part in the picture. Enjoy working freely with the texture of the brush.

When you are satisfied with the composition, make some marks with a lighter colour on top of the dark and see how this blends. Feel free in your use of the stylus.

The composition below was originally done on white paper. In my appraisal of the picture at the end I thought it would look more interesting with a coloured background and so I used the Fill Tool to put in the pink background. However, when the background was filled with pink it did look rather stark so I used the Airbrush to soften it.

Do not slavishly copy this example; choose your own colours but just follow the method.

Nearly all abstract art is rooted in something that the artist has experienced or seen. Later in this chapter (*see* pages 90-91) there is a group of still life pictures that have been abstracted by iPad drawing students; these illustrate clearly how abstraction is a personal thing, very much in the eye of the beholder. 'Abstract' is often regarded as the opposite of 'real', but in fact no pictures are 'real': they are marks depicting an idealized form of reality.

The next few exercises show how artists have interpreted what they have seen: abstracting reality, but on their own terms.

Fig. 8.6 Mondrian style tree with the oil brush.

EXERCISE 5
A tree in the style of Mondrian

The artist Piet Mondrian explored many forms of abstract expression in his productive career. Have a look at some of his work in books or on the Internet. He was always interested in the relationship of shapes to one another. At one stage of his life he was fascinated by trees and how shapes were formed in between the branches of a tree. He did a series of wonderful paintings on this theme. As we are looking at negative spaces I thought it would be a useful exercise to copy a Mondrian Tree. It was also interesting to see the type of strokes he had used in the picture and whether it would be possible to imitate these with the Oil Brush. Having just done an exercise with the Oil Brush this is a useful follow-on.

For my version I selected Paper Hatched, and then sketched out the tree with a fine Oil Brush. The image was copied from a black-and-white reproduction in a book and I chose to add very limited colour.

In an attempt to achieve a rhythm of the lines of the tree I painted quite freely, not aiming to copy the picture exactly but trying to reproduce the spirit of it and the pure enjoyment that Mondrian must have felt as he painted it, rejoicing in the shapes.

After sketching in, I chose Preset Thick Gloss, Size 10%, Pressure 50%, Thinners 0%, Loading 60%, Insta-Dry off, Auto Clean on, Square Head off.

The size of the brush was changed during the process but the other settings remained the same. I particularly enjoyed the limited colour of the picture and that it was possible to smear the paint so that there was a real build-up of textural marks. In some ways this was a disadvantage as when I wanted to put on some finer marks, the paint was too thick and the new marks were just gobbled up by the paint. In places the Eraser was used remove the paint completely and get back to the paper, so that some repainting was possible. Eventually the Pencil Tool was used to make some of the finer branches.

By looking at a master work and trying to copy the strokes in a very loose way, I learnt much about abstract painting and the use of the Oil Brush in ArtRage.

Now using the same paper and the same tools, try your own Mondrian tree, possibly basing it on a tree you can see in your garden.

EXERCISE 6
Abstract still life from everyday objects

At this stage we might consider making an abstract picture from everyday articles around us. In Chapter 4 we looked at a still life based on blue and orange. This still life was made up of articles that I had set up in my kitchen – items from around the house but chosen with the idea of complementary colours in mind.

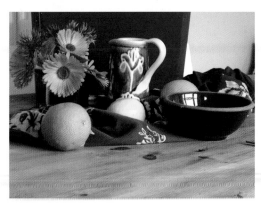

Fig. 8.7
The blue and orange still life

Fig. 8.8
First pencil sketch.

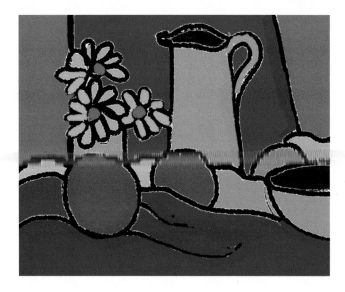

Fig. 8.9 **Abstract in blue and orange.**

Maurice Denis (1870–1943), a French painter and writer, said in 1890, 'Remember that the picture, before being a battle horse, a nude, an anecdote or a whatnot, is essentially a flat surface covered with colours assembled in a certain order.'

As before, I altered the arrangement of the shapes for this still life.

Select Paper Basic, Pencil, Size 20%, Pressure 50%, Softness 50%, Tilt Angle 25%, Precise off. Choose black to draw in the composition. Be aware of the shapes of the objects and how they relate to one another. The sketch shows how I played around with the shape of the jug. When I was happy with the shapes I went over the composition again with a thicker line, drawn with Wax Crayon.

As the picture was to be abstract I wanted to use flat areas of colour. Taking some of the colours from the photograph and using the Fill Tool, I just tapped on the appropriate areas. In many ways this process is like using a sophisticated colouring book. As the drawing had clearly defined areas it was very easy to use the Fill Tool. If you are following this exercise, tap on the centre of the area you wish to fill (do make sure that the outline is complete, otherwise the colour will leak out), and the colour will appear.

It was easy to change the colours by using the Undo button and to make subtle changes to get the right colour balance. In my version the small areas of the petals of the flowers were too tiny to fill and the Fill Tool did not work, so I used the Wax Crayon on a very small setting. There were some interesting accidents in my picture, like the white that is ghosting some of the black lines in places, which I have chosen to leave. Experiment more with drawing shapes and using the Fill Tool to add colour.

It was interesting to give a picture of this still-life arrangement to a group of students, and to see how they would interpret the same set of shapes and colours. The results are fascinating and show clearly that there is no single best way of achieving an abstract image. Interpretation is very personal. I am sometimes asked, 'What is an abstract painting?' To a certain extent all pictures are abstract, which is why this chapter is largely about personal expression. Here are a few examples of how the students interpreted the same image.

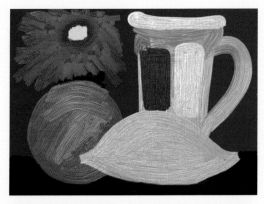

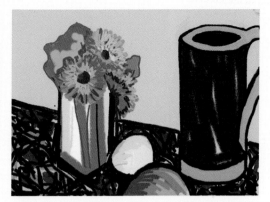

Fig. 8.10 Mary Clucas really enjoyed the simplicity of the shapes in the still life and chose the metallic paint option element to bring a shininess to the surface. Her picture shows a process of elimination where she has chosen to focus on just the objects that most interested her. The final result has a strength and presence in its honesty.

Fig. 8.11 Mary Langham's interpretation is also very personal. The strong black lines around the objects are reminiscent of the work of Patrick Caulfield, an English abstract artist who died in 2005. Done mainly with the Chalk Tool, the bold approach is very effective. There is a pleasing distribution of forms in the picture. The whole composition is on a blue background and the little areas of blue showing through on the cloth, provide a unifying theme.

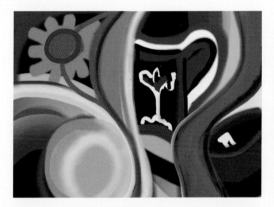

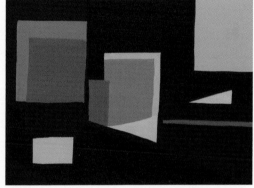

Fig. 8.12 This is a completely different view of the still life group of objects. Janet Phillips has abandoned any concept of space and has just thoroughly enjoyed the shapes she saw in the still life in a very imaginative and personal way. The composition swirls harmoniously over the whole surface of the picture.

Fig. 8.13 Angela Whitehead's picture illustrates an attempt at pure abstraction. Painting this type of image is much harder than it looks and depends on the perfect harmony of the shapes. This image works well both horizontally and vertically, which is always a good test of an abstract picture. Angela said that when she changed just one shape, the whole picture looked very different. The iPad is the perfect tool for this type of work as it is easy to make changes or go back to the previous version.

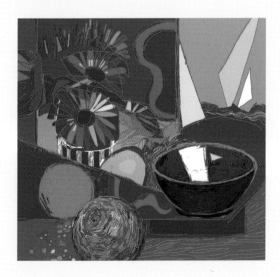

Fig. 8.14 This carefully worked still life by Judith Fletcher has exploited to the full, the theme of complementary colours. Judith has used strong geometric forms to underpin the whole composition and all the main shapes have been carefully placed in relation to one another. This picture shows how it is possible to exploit ones imagination when faced with a photograph and transform it into something very personal.

An abstract composition from your sketchbook

You can use work from your sketchbook or a picture in a magazine for abstract inspiration. Choose some unusual colours and try to make an abstract picture just using interesting shapes and textures. Select the colours carefully and think about the effect you want to create. For example, cool colours will tend to result in a very tranquil picture, while warm colours will produce a much more vibrant result. Use of the Fill Tool can dramatically change the appearance of a picture at the touch of a button.

Here are two examples of work produced from an original sketch done *in situ*.

EXAMPLE 1

Mary produced this simple line sketch on a day's sketching trip into town. Fortunately that day was cloudy and overcast, so it was possible to use the iPad outdoors. She used Inking Pen on Canvas Smooth.

She was not intending to produce a 'real' picture but was interested in the juxtaposition of flat colour shapes next to each other. To get a balanced picture is more difficult than it seems; for instance, the red figure in this picture is really important as it provides the centre of focus. Mary used the Chalk Tool, Fill Tool and the Inking Pen to make the picture.

Fig. 8.15 *Henley Market Place* by Mary Langham.

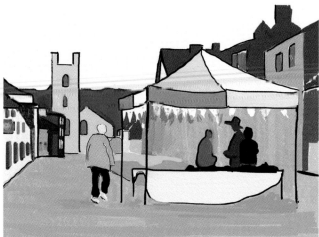

Fig. 8.16 Trying out different colours.

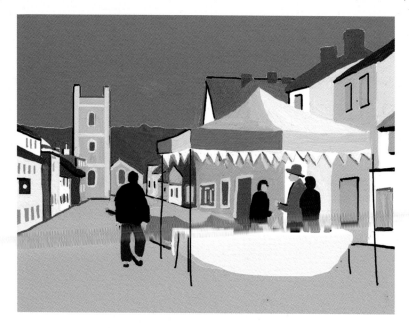

Fig. 8.17 Many colour combinations were tried using the Fill Tool but in the end this set of colours was chosen as being the most successful.

EXAMPLE 2

Here is another example of an outdoor sketch being transformed into an abstract image.

Initially a hard copy of the drawing was printed so that the abstract could be started afresh. The new composition was mapped in with a thin green Pencil line emphasizing the distribution of the main shapes over the surface. The upright of the tree against the diagonals of the field establishes some rhythm within the picture frame. A limited colour palette of greens and purples was chosen.

Paper Lumpy was selected and I drew in the main shapes with the Chalk Tool, on different size settings. Some of the finer details were added with the Pencil Tool. One great advantage of the iPad is that you can so easily change colours and shapes by use of the Eraser (it will rub out anything) or use the Undo button. Another advantage is that it is possible to save as you go along, enabling you to continue working on an image even if you think that improvements may not be totally successful. If you don't like what you have done, simply go back to your saved image.

Fig. 8.18 The sketch was drawn in my garden using Plain Paper and the Pencil. Tone was washed in with the Watercolour Brush.

Fig. 8.19 This is the abstract picture that was produced from the drawing.

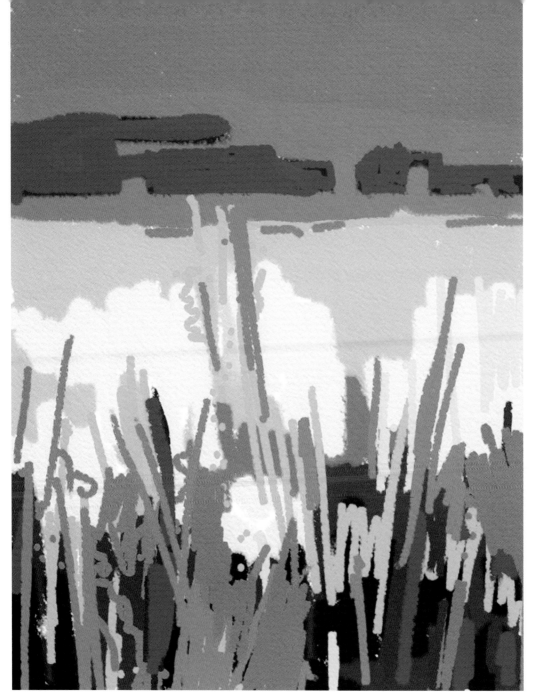

Fig. 8.20 *Hot Summer Landscape at Benson.*

AN IPAD SKETCH DIRECT FROM NATURE

This picture was made using only the Chalk Tool and resulted from a sketch in the countryside near where I live. It was high summer. The colours I chose were meant to accentuate the feeling of heat that I felt when I made the original sketch. Unfortunately I did not keep a record of the stages in making this picture – it went through various changes and colour alterations – and the ArtRage app does not keep a record of each step (unlike Brushes XP). To make a record in ArtRage you need to save your work regularly; this will give you a record of the steps you have taken. One of the marvellous things about this app is that you can draw so easily on top of existing marks. In my picture the colour was limited and the pink of the sky was deliberately used in the foreground, to connect with the background. Although the shapes are flat the picture does give some feeling of depth through the differing sizes of the shapes.

Try making an abstract landscape composed solely of geometric shapes. Look at the work of the painter Nicolas de Staël (1914–55) whose abstract work, mainly derived from real-life images, can inspire new possibilities.

Fig. 8.21 *Symphony in Purple* by Margaret Gill.

AN EXAMPLE OF PURE ABSTRACTION

This picture demonstrates the use of a wide range of tools and a deep awareness of the relationship of different shapes to one another. Every shape and colour has been put there for a reason to ensure the greatest harmony.

The subject of layers and how to use them has not yet been discussed (*see* Chapter 10) but this picture is an example of how they can be used in composing an image. This picture is made up of four layers.

Layer 1: Used for the pink and purple colours with the Oil Brush.

Layer 2: The Wax Crayon was used to give some texture.

Layer 3: Darker purple was applied with the Oil Brush; colours were blended together.

Layer 4: Thinner lines were added with Wax Crayon and Inking Pen.

It is clear that within abstract art there is plenty of scope for imagination, originality and freedom of expression. The next chapter, on Layers, offers further opportunity for experimentation.

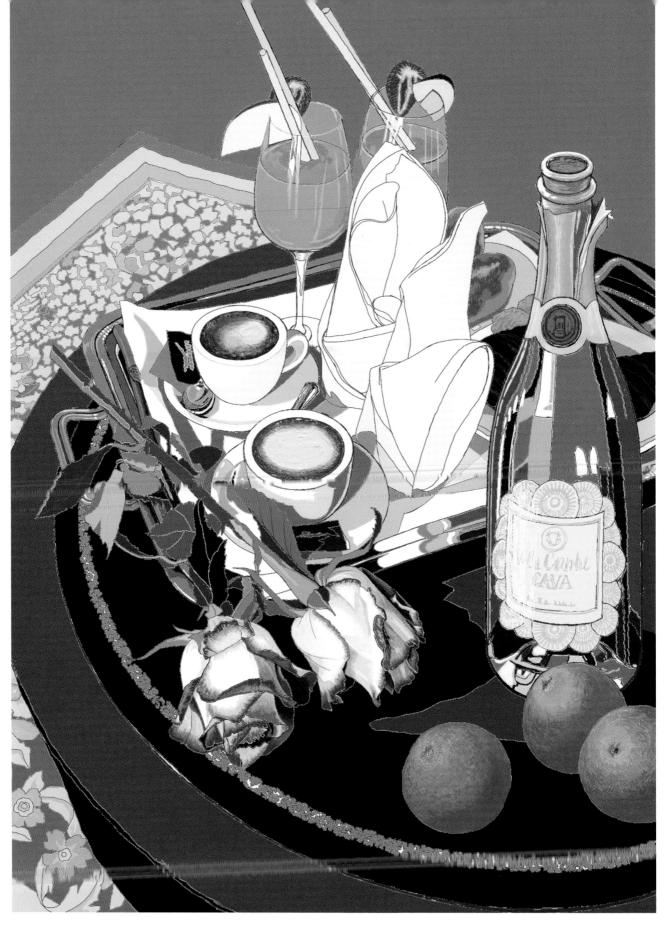

Fig. 9.0 *Celebration* by Judith Fletcher, a still life in four layers. There is a strong design sense underlying this picture; the square shape of the carpet against the oval of the table give a very firm base on which to arrange very differing objects. Advice that was given previously about the careful setting up of still life groups has been followed to the letter here. On the first layer Judith used various reference photos and the transform option to compose the still life. In the second layer she started filling in colour with the Fill Tool, all the shapes being quite flat at this point. Other textures and tools were used in layer three to bring more form to the objects. Finally different techniques were tried out on layer four. Unsatisfactory results were deleted and successful ones merged into the final image.

Chapter 9

Layers:
explanation and exercises

> The moment you cheat for the sake of beauty,
> you know you are an artist.
>
> **DAVID HOCKNEY**

f you look back to Chapter 2 where the screen was fully labelled, you will find an icon marked Layers, the fourth icon in from the bottom right corner of the screen. The Layers function enables you to create a picture by superimposing separate layers. Artists such as Rubens (1577–1640) and van Eyck (1395–1441) painted in a series of layers, magically building up from an initial stage of *chiaroscuro* to using thin glazes of almost transparent colour over each other. This way of working has fallen out of fashion but its basic concept is relevant here for the iPad.

If you are used to editing photographs, or have used Photoshop on the computer, the concept of layers will be more easily assimilated. If you imagine how a picture is made up, with varying sheets of paper all overlaying each other, some of which are semi-transparent, then you have understood the idea. You can get on very well without knowing anything about layers at all, but they allow you to add sophistication to your painting.

Fig. 9.1 When you first press on the icon Layers you will be faced with this screen.

Fig. 9.2 The various options listed on the screen.

Using Layers

When reading about layers, it would be immensely useful to have your iPad open and follow the processes described. Tap the layers icon at the bottom of the screen and a white rectangle will appear shown in Fig. 9.1. This represents the first surface you will work on i.e. Layer 1. The eye in the smaller rectangle represents the option to see that layer or not. You can close the eye by simply selecting it with your stylus and the layer will disappear from view.

The black circle next to the eye represents the opacity of the layer. Tap on this now with your stylus and a number screen comes up from the bottom of the screen. At first there is 100% opacity but you can change this by pressing the tiny cross next to the percentage and typing in the level of transparency you wish; then select return.

The final little icon represents a locking device. If there is one layer that you do not wish to be altered in any way you can lock it.

Select New with the stylus to make a new layer. Next to the word New, the little square with small lines across represents a series of layer options. Select this icon now and you can see what they are. This might seem a bit complicated at first but after a few simple exercises it will become clear.

LAYER OPTIONS

IMPORT IMAGE
Select Import Image if you want to use a photograph in a new layer. Select this line now and you will see you have two possibilities: either to import an image that you have already in your photo gallery or to take a photograph. To import an image from the photo gallery, select that heading and then all your photos will appear. Simply tap on the chosen image with your stylus and it will appear on your layer immediately. If you choose to take a photo, a small screen will appear at the bottom right-hand corner. Select your view and tap the Take button. You will then have two options: to re-take or use the photo. If you tap Use, the photo will appear on your screen and then you can move it around or re-size it. Then tap Done in the bottom left-hand corner of the screen.

DUPLICATE LAYER
This will reproduce an existing screen layer onto a new layer so you can manipulate it without disturbing the original layer. It is a very useful function.

TRANSFORM LAYER
This enables you to move an image around on the screen. Draw a simple circle on Layer 1. Select the Transform option and you will see that the circle is surrounded by a dotted square that has little hooks at the corners and in the middle of each line. Select these to move the image the way you want it to go. This function works best if you place your stylus in the middle of the shape and move it gently to where you want it to be, otherwise the proportion of the picture might change. It is also possible to expand and contract the shape by putting two fingers inside it and altering its size. When you are happy, select Done in the bottom left-hand corner and the shape will remain in its new position.

CLEAR LAYER

If you are in the middle of a picture involving layers and you decide there is a layer you want to clear and start that layer again, simply tap on this heading and the layer will clear. It is also quite a useful function if you want to clear a screen quickly and easily; it is not necessary to be using several layers to use this function.

DELETE LAYER

This will get rid of a layer completely.

MERGE LAYER DOWN

This will unite two separate layers into one.

MERGE ALL LAYERS

This will merge all your layers into a single image.

CANVAS SETTINGS

If you decide, when you are half-way through your picture, that you do not like the surface you are working on, you can change it by pressing this option.

CANVAS LIGHTING

When this option is selected, the tonal balance of the picture is darkened.

NAMING THE LAYERS

When creating a picture with many layers, you may wish to name each one. With the layer you wish to name highlighted in green, simply select the No Name title with your stylus and a keyboard will appear. Select the small cross at the end of No Name and you are ready to type in your chosen title for this layer. It will then automatically appear on that layer; then select Return.

Practising with Layers

A picture with 3 Layers. To make Layer 1 (Fig. 9.3) choose Paper Basic, and leave it white. Remember to pinch in.

Select Chalk Tool, Size 25%, Pressure 100%, and with a fairly dark colour. Draw some simple flower shapes.

To make Layer 2 (Fig 9.4) select the Layers icon and then New. A second layer will now appear. This is highlighted in green and shows that this layer is active. *Note: whenever you wish to work on a layer, it must be highlighted in green otherwise it will not be active.*

Choose the Roller Tool, Preset Thick and Smooth, Size 10%, Pressure 25%, Thinners 0%, Loading 50%, Auto Clean on.

Fig. 9.3 You now have Layer 1.

Fig. 9.4 Layer 2.

Select a different colour and make some large marks over the surface. Select New again to make the next layer.

Before doing anything on Layer 3 (Fig. 9.5), close the eye on Layers 1 and 2. Do this quite firmly by pressing with the stylus on the eye. Now (making quite sure that Layer 3 is highlighted in green) select the Fill Tool and a fairly dark colour. Tap on the picture and the whole screen will fill with your chosen colour.

Go back to the Layers option again. Tap on it and you will see there are three separate Layers. Now open the eyes again and you will see that Layer 3, which is totally opaque, is obscuring Layers 1 and 2. Now you just need to shuffle your layers around. Tap on Layer 3 making sure that it is active and drag the layer down to the bottom to replace Layer 1. This may be difficult initially but with practise it will work. Now that the opaque layer is at the bottom, the other two images can sit on top of it. Mix the layers around and see which arrangement gives the most pleasing picture.

Practise for yourself now. Make a picture with more layers and see, by shuffling the layers around, how it is possible to come up with some surprising and interesting results.

EXERCISE 2
Moving simple shapes

In London in 2014 there was a major exhibition at Tate Modern of work by Henri Matisse (1869–1954). In the exhibition, film footage showed an aged Matisse sitting in a wheelchair making pictures from cut pieces of paper. He cut interesting shapes, sometimes abstract, sometimes figurative (the blue nudes, for example) from plain, brightly coloured pieces of paper. He then asked his assistants to pin these brightly coloured pieces of paper to a surface on the wall. Matisse indicated by the use of a long stick exactly where these pieces of paper should go.

The next Layers exercise is based on this concept of moving simple shapes around until you have an interesting abstract picture. (The importance of negative shape was mentioned in the Chapter 8.)

Fig. 9.5
Layer 3.

Fig. 9.6
This is the finished picture after the layers have been transposed.

Fig. 9.7 Layer 1. Start by selecting Paper Basic, and pinch in. Use the Wax Crayon Tool, Size 45%, Pressure 65%, Softness 100%. Draw a simple shape in a primary colour and fill it in with a plain colour.

Fig. 9.8 Layer 2. Select the Layers icon and you will see Layer 1 with the single shape. From Layer Options select Duplicate Layer. This will create a second layer exactly the same as the first. With Layer 2 highlighted in green, press the Options icon and select Transform. With the stylus placed in the centre of the shape, slowly move it to a different place on the screen. When you are happy with the position of your shape, select Done in the bottom left-hand corner. It should be placed in a good relationship to its neighbour.

Fig. 9.9 Layer 3. Go back to the Layers Icon again and press New to make a third layer and draw, still using the same tools, a different shape of contrasting colour. Select Layers Option again and create a Duplicate Layer of this second shape.

Layer 4 (not illustrated). With Layer 4 highlighted, select Transform again and move the shape around until you are happy with the composition. The shapes left by the white paper should form a dynamic part of your composition.

Fig. 9.10 Layer 5. When looking at Layer 4 it was decided a fifth shape was needed to complete the composition, so Layer 3 was highlighted again and Duplicate Layer was pressed. This extra shape was transformed into a smaller shape. There are now five Layers.

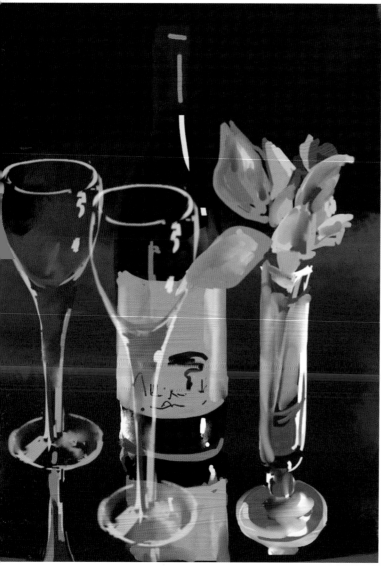

Fig. 9.11 *Valentine's Day* by Janet Phillips. This picture puts into practice all the elements looked at in the previous simple exercises.

STILL LIFE: EXAMPLE OF WORK USING MULTIPLE LAYERS

This series of pictures shows very clearly how the image was built up and how very different this process is from using just one layer in a picture. Janet's idea was to make a still-life picture with a bottle, glasses, a rose and a vase. She had the actual objects in front of her, but she was not sure how she wanted to position them, so by using layers it was possible to alter things very easily. For example, the position of an object could be changed by using Transform or by using Duplicate Layers.

Fig. 9.12 Layer 1. Paper Basic was chosen and it was coloured dark green on the initial screen. Working on the green ground, the Chalk Tool was chosen to sketch out the composition.

Chalk Tool, Size 5%, Pressure 10%.

The rose in the vase was then blocked in, still using the Chalk Tool, but on a larger setting and greater pressure.

Fig. 9.13 Layer 2. Make a new layer and close the eye on the First Layer. The bottle was painted using the same tools as Layer 1, with the addition of the Inking Pen.

Fig. 9.14 Layer 3. A new Layer was made. The eye on Layers 1 and 2 was closed and the wine glass was drawn with the Inking Pen.

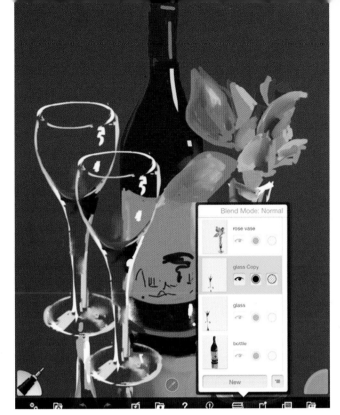

Fig. 9.15 Layer 4. A new Layer was made. The artist then decided that two wine glasses would look better in the composition so she duplicated the wine glass from Layer3 onto Layer 4. The eyes were then opened from the other Layers and this second wine glass was subjected to the Transform option and moved till it was in a good position in relationship to the other objects in the picture.

Fig. 9.16 Layer 5. It was then decided a more interesting background was needed. The eyes on all the other Layers were closed so that one could work freely over a blank screen. The background was painted with a Roller, Oil Brush and Palette Knife and then dragged to the bottom of the file to become Layer 1 and sit behind all the other objects.

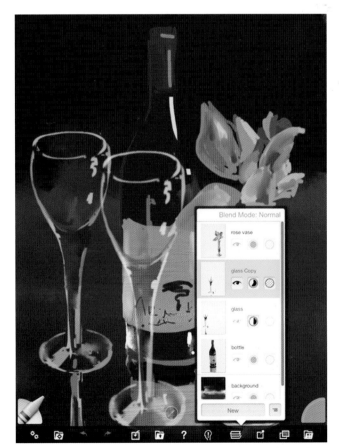

Fig. 9.17 Layer 6. The final picture shows the completed still life including the finishing touches that were made to the image. The transparency of the glass and the bottle were increased by decreasing the opacity and the rear wine glass was made slightly smaller; more work was done on the rose vase.

Although this final still-life picture might look too complex for a novice iPad user, it is worth experimenting with the Layer facility to make your own five-layer still life using some of the techniques shown here.

The next example using Layers shows a very different subject matter and a more delicate approach. Angela loves painting flowers on her iPad and has developed great skill in using the chosen tools to interpret petals and leaves.

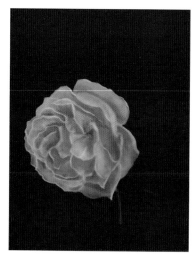

Fig. 9.18 Layer 1. Paper Basic was chosen and coloured green on the initial screen. The rose was drawn from a photograph and was not traced or imported from the gallery. The whole shape was first drawn in pink on the green paper with the Chalk Tool, Size 2%, Pressure 2%. Then the Airbrush Tool was used, Size 28%, Blend Mode Normal, Pressure 40%, Tilt Angle 0%, Taper Length 0%, Opacity 30%. The whole rose was built up gently, varying the size and pressure of the Airbrush. Petals were gone over many times to build up their texture, and more definition was added gradually.

Fig. 9.19 Layer 2. It was decided that another rose was needed to complete the composition. A new layer was made and the eye was closed on Layer 1 and the second rose was drawn on Layer 2. After this was completed the eye icon was opened on Layer 1 so that the two roses could be seen in relation to each other. It was clear that the sizes of the two roses needed to change to make them fit together in a harmonious composition. Layer 1 rose was transformed to make it somewhat smaller. Layer 2 rose was also made smaller and moved up the page slightly. The two Layers were then merged, and slight painting adjustments were made with the Airbrush so that the effect was more realistic.

Fig. 9.20 Layer 2. After merging the two images.

Fig. 9.21 Layer 3. It was decided a different background was needed. This was made on a separate Layer using the Airbrush Tool with different colours and a few vague shapes. The Palette Knife was then used on these shapes with the setting of Instant Blur and Harsh Chaos. The background was then dragged down the layer pile to be behind the two roses.

Fig. 9.22 The finished picture makes a wonderful composition and reflects the delicacy of the roses. As you can imagine, this was not done quickly.

Fig. 9.23 Portrait by Janet Phillips. This portrait was painted from a photograph by Jane Bown.

Fig. 9.24 As the portrait was worked on further, it became obvious that it would be easier to add a different layer to do the hand.

Fig. 9.25 The finished picture.

PORTRAIT PROJECT USING LAYERS

The student who created the image above started with a mid-tone terracotta background so that the light and dark tones would show up. The outline was sketched first using the Oil Brush Preset Normal Round on a very small size. After the first sketch the face was gradually filled in using varying sizes of brushes; colours were selected carefully to reproduce the photograph on which the portrait was based. Staying with the Oil Brush but on a smaller size the student used maximum Opacity and maximum Pressure for the hair.

On assessing the picture it was realized that the whole thing would look better if there was a more lively background. The purple background was chosen as a complementary colour to the orangey tones in the face. This was made with the large Oil Brush, using haphazard and lively marks; then this third layer was dragged to the bottom of the pile to go behind the face.

This chapter has opened up many new possibilities; you will need time and plenty of practice with using layers to make the most of the potential of this facility.

Fig. 10.0 *Hellebores* by Janet Phillips. This picture illustrates well how the iPad can be used in conjunction with photography. From some initial shots of hellebores, she made a harmonious composition and by painting with the Oil Brush a wonderful backdrop for the whole picture was achieved.

Chapter 10

Working with **photographs**

> All painters are interested in photography to a certain extent.
>
> **DAVID HOCKNEY**

Taking photographs

n the previous chapter, layering technique was explored in detail, and a key aspect of this function is the ability to import and use photographs. Using your iPad to take photos is therefore explained here.

On the initial iPad screen where all the different apps are displayed, you will find a camera icon. Select the camera icon and you will be faced with the screen (Fig. 10.1) or something similar.

At the top right-hand corner there is a small camera icon. This indicates whether the lens looks outwards (towards what you see) or inwards, where you can see yourself and what is behind you. This makes taking a 'selfie' very easy. Try selecting it now to see what it does.

HDR stands for High Dynamic Range, and can be turned off or on. With HDR on, the camera will take three photos of different exposures and then blend them into one, so that in a landscape you will see the detail in the clouds as well as in the darker ground beneath. It is useful for photos of landscapes with high contrast, but not suitable for moving subjects.

Fig. 10.1 The camera screen.

The white circle is the 'button' for taking the photo.

Beneath this are three options: Video, Photo and Square – Square meaning that you can take a square photo. (The iOS 8.0.2 iPad camera also has time delay and time lapse options, but these will not be discussed here.) To change between Video, Photo and Square options, slide or tap with your stylus. In Video mode, the 'Take' button will turn red.

To zoom in when taking a photograph, pinch the screen and a line will appear at the bottom. There is a plus and minus sign at either end; just move the stylus or your finger along the line towards plus or minus and stop when your required image is reached. Now take the photograph. This will automatically be saved into the photo app, enabling you to access your photos very easily.

Editing photographs

Another facility on the iPad that may aid creativity and inventiveness is the ability to edit photos. Select the Photos icon on your initial screen. Choose a photo and in the top right-hand corner the word Edit will appear; select this and you will see a further series of options.

It is possible to revert to the original image after editing but you may wish to save the edited version *and* the original, in which case you can email the original version to yourself.

Tap on the various icons for each one to reveal what it does. In the iPad version iOS 8.0.2, options to edit are listed down the left-hand edge of the screen. (*Note*: because the technology is evolving quickly, the icons may not appear in exactly this order.)

ENHANCE

This enhances the tonal variation. When you select the Enhance icon it will turn blue, with the picture changing visibly. Then select Done and the picture will be automatically saved into photos.

CROP

This is the facility to alter the shape and select portions of the picture. Place the stylus on the corner and move it to select the portion you want to include in your final image. When you are satisfied with the result, select Done in the top left-hand corner. This cropped picture will then be saved into photos. There is also the facility here to tilt the picture in an interesting way.

FILTERS

This is one of the most exciting features. Bring up an existing photo onto the screen. Select Filters and you will see many possibilities of how the photograph might be viewed. Try each filter and see how it changes the picture. This reveals how colour and tone can transform an existing image. Simply select Done if you are happy with your altered image.

LIGHT

You can alter the light in the photograph; there are numerous sub-options for this category – too many to describe in detail. Experiment freely with everything on offer, and if any of the effects enhance your image, select Done.

RED-EYE

This feature can be very useful for removing red-eye when photographing people.

DELETING PHOTOGRAPHS

Select the photo you want to delete by pressing on it. It will now appear full screen and in the bottom right-hand corner a dustbin icon will appear. Select it and a small note will ask if you wish to delete the photo; select this to confirm.

Fig. 10.2 A picture based on a photograph with added manipulation and some painting.

Using photographs in your artwork

Having learnt how to manipulate photos, you can now make some pictures of your own by adding some of your own painting and drawing on top of the image.

This picture was made in response to a call for work for a specific exhibition. First an iPad photo was taken of the Town Hall in Henley-on-Thames. The picture was then edited using the Filter function – the Process filter gave a blue tinge to the image.

Fig. 10.3 Photograph after the blue filter had been applied.

This was automatically saved into Photos so that it could be accessed in ArtRage. After bringing the image onto the ArtRage screen and selecting the Layers icon, a duplicate image of the photo was made on a second layer. This second layer was then subjected to the Transform icon. After that the Fill Tool was used in various areas of the picture and specific areas were filled with different colours. The Airbrush and Chalk Tools were used to complete the picture. It was then printed commercially on canvas (20×20cm) and submitted to the exhibition.

Fig. 10.4 **This is a multi-media picture using four layers.**

Importing an image from the Internet

To use an image that is not available already in Photos it is possible to import one from the Internet.

Open Safari on your first screen and type in the subject you require, e.g. 'pictures of birds' (always include the word 'picture' in what you type). A series of images will then appear on the screen. Select the one you want to import; this should then bring this single image on to the screen. You may need to select View Image too. Select and hold on the picture and then select Save Image. This goes directly into Photo gallery.

IMPORTING AN IMAGE FROM THE INTERNET AND DRAWING/PAINTING OVER IT

The picture above (Fig. 10.4) was started using an imported image which was then drawn and painted over; finally the large head was imported and incorporated into the picture.

I chose Rough Paper to work on. For Layer 1 a picture of leaves was imported. On Layer 2 I worked with the Roller on the Rough Paper (this gave an interesting texture), and then worked on top of this with the Chalk Tool.

Layer 3 was a piece of pink paper made with the Fill Tool. After playing around with the layers I used just 50% opacity on this layer.

Layer 4 was the imported head image from the Internet, at just 40% opacity.

There was a lot of experimentation with the order of the layers, and with the opacity.

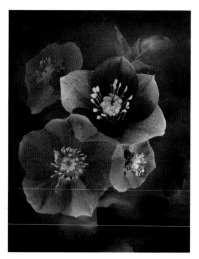

Fig. 10.5 *Hellebores* by Janet Phillips.

Fig. 10.6 **Screenshot of hellebore picture showing the layer table.**

EXAMPLE OF A PICTURE USING LAYERS, PHOTOGRAPHS AND PAINTING

The picture that fronts this chapter was made in six layers and is heavily dependent on photography. First, four different hellebore flowers were photographed against a dark background. Each separate image was then imported from Photos into separate Layers. The Eraser, first on quite a small setting, was used to rub out all the background on every layer and leave the flower image totally isolated. Each flower went through a transformation process; it was made smaller or moved. Then the Opacity of each image was experimented with so that the images would fit together: the ones at the front were stronger; the ones at the back were lighter so they would recede. There was also much experimentation to see how the flowers would fit together – for example, the small image at the top left of the image was replicated by transformation in the bottom right. When the arrangement of the flower heads was complete a background was included. The colour palette of the flowers was utilized to make a background using the Oil Brush, smeared with the Palette Knife. This layer was then dragged down to the bottom of the pile to go behind all the other images.

Using imported photographs and layers

Layer 1: Select a paper to work on and pinch in. Select the Layers icon and import an image from the Internet. Close the eye icon on Layer 1 before working on layer 2.

Layer 2: Selecting any tools, make some marks over the paper. The colours chosen might relate to Layer 1.

Layer 3: Make a plain piece of coloured paper with the Fill Tool.

Layer 4: Import another image from the Internet.

Now experiment freely with moving the layers around to find the most harmonious combination. Try different opacities on each of the layers.

Fig. 10.7 The reference screen showing the pinned image and the table for reference icons.

Using photos with the Reference icon

The Reference icon, next to the Layers icon, looks like a clipboard. This is the icon that allows the iPad user to import a photo for reference purposes; this is very useful if you want to work directly from a photo and you want the reference on the screen as you work.

When you select the Reference icon, there is a choice either to import an image or take a photo. Selecting Import an Image will take you directly to Photos where there is a choice of all the images you have taken or imported. Select the desired image and it will automatically appear on the screen as a small pinned photo, as shown below.

By putting two fingers on the edges of the photo you can manoeuvre the picture around the screen and put it where you want it, in order to have enough screen to draw on. It will go much smaller, but not much bigger. Once the image is on the screen the clipboard icon can be pressed again, giving a further series of options. The small inset screen shows

the imported picture and an eye and a small box. The eye has been seen before in Layers and it performs exactly the same function. The small box will show a series of reference options. Reset, Size and Rotation are quite obvious. Hide Reference will make the image disappear from the screen and will close the eye. Remove Reference will take the image away completely. Selecting New at the bottom of the small screen will enable you to import another image, if you wish to work from two images simultaneously. This may seem far-fetched at the moment but as you get more competent you may find this a useful option. The small square next to New just replicates the other options.

The Reference photo will simply disappear as you draw near to it. It is possible to pick up colours from the Reference photo by simply tapping on the chosen colour in the picture and it will appear in the Colour Pod. Even if it is not quite the required colour, subtle changes are easily made. Remember to remove the Reference photo when the picture is finished, before saving it to Gallery. Do this by selecting the small square with the lines in it, next to the eye icon. Amongst the options Remove Reference is clearly visible.

Fig. 10.8 Original imported picture from the internet by Mary Langham.

Fig. 10.9 Reference photo pinned to the screen.

Fig. 10.10 Starting to draw with the Marker Pen Tool.

Fig. 10.11 Beginning to smear the colours with the Palette Knife.

EXAMPLE OF A PICTURE CREATED USING THE REFERENCE ICON

Initially Mary selected her Reference photo from the Internet (already on a black background) and imported it. A black piece of paper was made with the Fill Tool.

Remember it is possible to pick up the colour you want to draw with by tapping on the original colour in your reference photo.

Select the Palette Knife Tool (Fig. 10.11), in a small size, set to Hard Out Smear, and pull the colours about until the desired effect and shape are created. The edges of the tulips can be blurred by setting the Palette Knife to Blurred Frosting. When the painting is finished remove the Reference image by clicking on the Reference icon, then on the small box to the right of New. Tap on Remove Reference Image and the imported image will disappear.

ANOTHER POSSIBILITY USING THE SAME PHOTO

In this picture the original photo had various colours added with the Chalk Tool and then the Palette Knife was used on Hard Out Smear to complete the picture.

Reference Image can be used in countless exciting ways, not necessarily simply for copying, but also as a starting point for some interesting work.

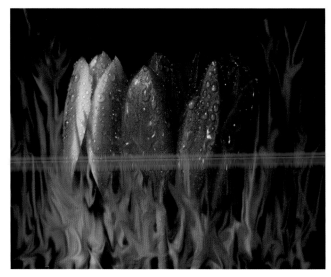

Fig. 10.12 *Fired Tulips* by Mary Langham.

Using the Tracing icon

Next to the Reference icon is the Tracing icon (two sheets of paper on top of each other) which gives the ability to trace from an existing image or photograph (either your own work or an image downloaded from the Internet).

When you select the Tracing icon a small screen gives you the option to import an image or take a photograph. When you select Import Image you will see your Photos. Scroll here to find your chosen image and select it. The picture will arrive ready to use and will look as if viewed through tracing paper. When you select the Tracing icon again a small tracing panel will appear (bottom right). You will see your chosen image at full intensity and at the side of it, an eye and the Transform icon which looks rather like a compass. This will only work if you select the small square under the transform icon. Here you will be faced with a series of tracing options but first you need to select the bottom one, Image Scale. You are then faced with another series of options. Select Manual Scale; tiny hooks will appear around your photograph and you will be able to transform it using two fingers.

More tracing options appear under the Transform button, but these lie outside the scope of this book.

At the bottom of the small screen there is an Opacity scale. This allows you to change the Opacity of the picture you have just imported. To alter the Opacity, simply select the word and a numbers keyboard will appear from the bottom of the screen; type in the Opacity that you require. With

low Opacity you can see quite clearly a traced line over the existing image. Although this is known as the Tracing option, it is not necessary to use a Pencil. You can use any tool over your imported image. Options are numerous, so you could carefully trace and then meticulously paint over the tracing or simply launch in with the paint straight away.

Sending photographs or pictures of your work

To send a photograph that you have taken or send an image that has been stored in the gallery (all Zen Brush work is stored in Photos), first select the Photos icon on your main screen.

Select your chosen image; it will then fill the screen. At the bottom of the screen, the icon that allows you to send the image is represented by a small rectangle with an arrow in it. Select this and you will be faced with a new screen that shows your chosen image with a small blue tick on it. This screen also gives you options of where you would like your image to go; simply select the one required. For now we will look at the email option.

Select the icon marked Mail and a new screen will appear, showing your chosen picture with a space at the top allowing you to type in the address of the recipient (this person can be yourself). When you have done this, typed the subject heading and added a message if appropriate, select Send.

To be able to print your image you must first send it to a computer; however if you have a wireless printer you can send it directly to the printer.

To send an image from your ArtRage Gallery

This process is almost the same as sending from Photos, with just a few minor variations. You will need to know this process if you are eventually going to print your images.

To get your chosen image on the screen there are two possibilities: either access all your images through the Gallery icon in the top right-hand corner of the Gallery screen (here you can scroll very quickly and easily through all the images you have made), tap on it and it will appear on your main screen;

Fig. 10.13 The tracing screen with imported image and the table of tracing icons.

alternatively just scroll through Gallery till you find the one you want. Underneath the picture at the bottom of the screen there are two different icons: the dustbin icon, which allows you to delete the image, and a rectangle with an arrow in it. This is the icon that enables you to send the image. Select the arrow and a table of export options will appear. The only options that are relevant now are the third one, and the bottom one. Send by Email, and Print Picture.

Choosing Send by Email will send the image to a computer that enables you to print. Having selected Send by Email there will then be a choice of PNG, JPG, or PTG. A detailed definition of these acronyms can be found on the Internet, but for our purposes, JPG is appropriate for sending images because it makes the files smaller by compressing the number of pixels in an image. (It is good for photographs, but not for fine line images.) After selecting JPG another screen will appear, showing the chosen picture; the email address can be typed above it.

Printing your work

If you wish to print your work it is necessary to transmit the image from your iPad to a printer, and method will vary according to what kind of printing equipment you have.

If you are going to print through a computer, you need to send your image as an email attachment (as described above), then open the attachment and print. You will usually be offered the choice of printing one image per A4 sheet, or several images on one page.

If your printer is wireless you can print directly from your iPad. To do this, instead of clicking on Send by Email, click on Print Painting, the last option on the Export table. At the time of writing, this technology does not give the same possibilities as printing from an email and does not give the option to size your image.

It is advisable to use special paper to print on, and to feed the paper into the printer in single sheets. (Remember that the paper needs to be put in the printer with the printing side down.)

By now you probably have quite a few pictures worth printing, and you may be considering framing the prints. David Hockney at one time sent images to his friends every day – usually just a small picture print of a posy of flowers; you will probably be more reticent about sending pictures prints until you feel more proficient. Or you may be like a group of adult students I taught recently, who were often so proud of what they had done they immediately dispatched their newly drawn images over the Internet, often with the comment, 'Look what I did!'

The intended final destination of your printed image has a bearing on how it should be printed. Three important points to consider are permanence, ink and paper quality. Are you going to exhibit this in an exhibition, send it as a card to a friend, or just stick it in a book where you record what you have achieved?

When Hockney made his series of iPad drawings 'The Arrival of Spring in East Woodgate', he knew as he drew that it was going to be printed, and it was made on four large sheets of paper, 93×70 inches. This large scale type of printing is not normally available to the amateur iPad artist.

Certainly if you feel you cannot print the image yourself you can send it electronically to an online printing service, or even to your local printer. When you are having it printed you will need to give full instructions as to the kind of paper you require, the size you want it to be, and the permanence you expect from the inks.

There is also the possibility of getting your image printed onto canvas. Search the Internet by typing in 'canvas picture prints' – there are many companies offering this service now. Typically the price of a 24×16in (60×40cm) canvas is £33, which compares very favourably with buying a frame. These printed canvases can easily be hung directly on the wall without a frame. You must specify when you send the image to the printing company whether you want the edges printed as well, as the edges of the canvas will be visible.

If you are going to print the picture yourself you need a good paper and good inks in your printer; high-quality printers and excellent paper are now available to amateur artists at a reasonable cost. Small quantities of paper can be obtained by searching on the Internet. The best quality paper has a special coating, allowing the ink to soak into the paper, whereas the cheaper version – standard copier paper –dissipates the ink.

When I am printing on special Fine Art paper, about £1 per sheet for A4 size, I check that I have got the size and colour basically right by putting a cheap sheet of paper through the printer first before printing on the expensive stuff. When you compare the prints on cheap paper and expensive paper next to each other you will see the dramatic difference: it really is worth the extra expense.

The number of different papers available for the home printer is vast. I have been fortunate to find a supplier who will send a trial pack of ten different sheets of Fine Art inkjet paper of different weights and textures at a very reasonable cost. Your standard stationery store may well sell paper for printing but often you have to buy at least ten sheets of the same kind of paper at a time. Unfortunately a lot of trial and error may be necessary to see what weight of paper will go through your printer and what kind of finish you like best. If you are feeling truly adventurous you could try to put a lot of different printing surfaces through the printer. Thin cloth stuck firmly onto paper will give you an interesting but slightly dull print. Overhead projector film is also fun, giving a delicate misty image that can be mounted onto different kinds of backgrounds. Print on the rough side of the film so that the ink has something it can adhere to. Kitchen paper is another possibility – although it will soak up much of the ink. I would not recommend any of these techniques for an archive but they are highly creative and great fun. Bits of such prints could be cut up and used in multimedia work.

An inkjet printer is entirely suitable for printing your iPad images. Laser printers are also available but these are mainly for commercial printing and are used for printing long runs of such things as leaflets, when thousands are needed. The cartridges, which are expensive, are intended to be capable of printing 10,000 images. The printers also function in a different way, the laser printer heat-fixing the image and the inkjet squirting pixels of colour.

If you are buying an inkjet printer, buy a well-known make, so that maintenance does not become a problem and it is easy to obtain replacement cartridges.

I suspect that for someone just starting with the iPad, the question of higher resolution is not important; however, as you progress you may want to learn more about pixels and resolution of images. High resolution means that there are more pixels per square inch and this will give you a sharper, clearer print.

Framing your work

Once your iPad picture is printed, what are you going to do with it?

There are many fairly cheap standard sized frames on the market now, and it is possible to go into a shop with your print and see which frame is the most suitable. The print usually looks best if there is some space between the edges of the frame and print itself (usually made of cardboard and called a mount. Some frames are sold with a mount already included.

If a standard mount is not suitable you have two choices: either ask a picture framer to cut you a new mount or buy a mount cutter so you can cut the mounts yourself. These are readily available at art shops and online. They are not cheap but if you are intending to do a lot of work they will repay the initial outlay. Alternatively you could share one with friends and all contribute to the cost. At the start, a mount cutter can be quite daunting and some practice is needed to master the skill. It is possible to buy mount board from your art/craft shop of the colour and weight to suit your frame and print. It is important to make sure that the blade in the cutter is sharp so it will cut the mount accurately and easily.

Selling your work

If you plan to sell your work, you should be extra diligent about the resolution of the image, paper quality and the permanence of the ink used. The image should be under glass to protect it. When hanging an expensive watercolour picture you would not hang it in strong sunlight; the same is true for an iPad print.

The print should be signed by hand and have a limited edition number, for example 1 of 20, or 10 of 100, etc. I have struggled to find exactly the right place to do this, whether on the print itself or on the mount. The way your work is signed should complement the print, not dominate it (beware of black pens on subtle prints, for example).

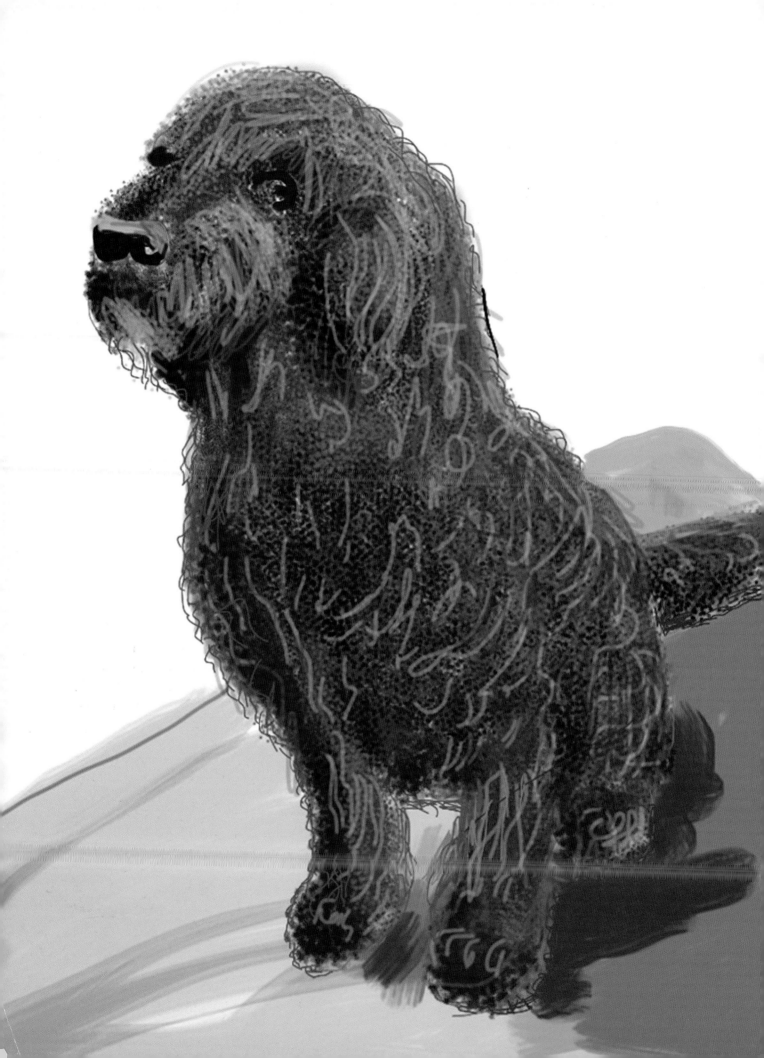

Overview of other
apps

I see the iPad as a wonderful new drawing medium,
but I am at a loss as to how to make it pay.

DAVID HOCKNEY

There are many excellent painting and drawing apps on the market and there will probably be more by the time you have this book in your hand. I chose to work with ArtRage because, with my background in Fine Art, I felt that that it had the greatest range of tools that would be suitable for an in-depth study of painting and drawing on the iPad. Its wide range of options also give the artist the opportunity to make numerous refinements to a picture. Equally, ArtRage can be used to do simple drawing without needing to know anything about layers or photo editing.

The various apps covered here are readily available to purchase in the app store, which is on the main screen of your iPad. (Purchasing new apps is covered in Chapter 1.) The app that is probably the most familiar to the general public is the one that David Hockney used called Brushes.

The picture opposite was created by Margaret Gill using the Brushes app. Everyone knows that animals will never sit still to be drawn, so Margaret worked from a photograph. The picture was made in layers. On Layer 1 the dog (Dilly, the labradoodle) was drawn out roughly. On Layer 2 the base colours were mapped in. On Layer 3 details were gradually added and on Layer 4 highlights and finishing touches.

Fig. 11.0 *Dilly* by Margaret Gill. This lovely image of the dog was done with the Brushes XP app. Its success is based on some careful observation and important little touches like the small light in the eye and the strong shadow under the body of the dog. The lively textures shown here are very typical attributes of this app.

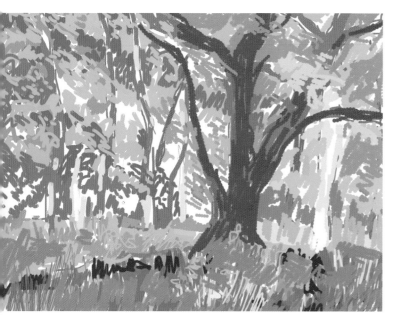

Fig. 11.1 *Bluebells at Nettlebed.*

The image above (Fig. 11.1) was painted very early in my iPad career, using Brushes 2. I took the iPad out into a local wood and sketched directly what I saw. There were no layers involved – in fact at this point I did not even know what layers were! It was a delight to sit in a wood with just my iPad and stylus. After first sketching in the lines of the main composition with the thin brush I began to fill in the colour, working forwards from the back as in traditional painting. To get the right greens was quite a struggle.

How to use the Brushes App

The iPad landscapes by David Hockney exhibited at the Royal Academy in 2012 were created using Brushes 2. These landscape pictures have also been widely reproduced in books. If you are keen to replicate any of these images you may find it difficult, as this particular app is no longer available for purchase. Brushes 3 was more complicated to use, though it did provide some interesting textures and is quite different from ArtRage. But then the iPad software was updated and as Brushes 3 was not fully supported by this update it ceased to work properly. Do not download Brushes 3, as it will not work fully even if your iPad is fully updated.

Recently a new version has been issued called Brushes XP, which works in the same way as Brushes 3. After reading the brief overview below, hopefully you will be encouraged to give it a try. Most of the skills learnt in ArtRage are transferable: colour selection and layers, for example.

GETTING STARTED WITH BRUSHES XP

Download Brushes XP from the app store and select the Brushes XP icon on the main screen. You will now have the first Brushes page in front of you.

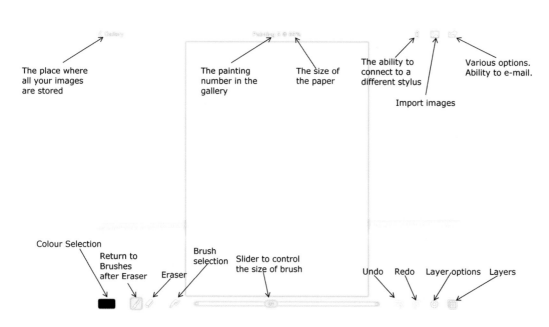

Fig. 11.2 Brushes screen showing icons.

When you buy this app it will come with a picture of an apple. Tap on this and the apple will appear full screen. You will now be faced with a triangle inside a circle. Tap on this and it will show you how the apple was drawn. The Brushes XP app has this replay possibility as it automatically records the way in which an image is made. To activate the replay on any of the images stored in the gallery, tap on your chosen picture to make it appear full screen. When a triangle inside a circle appears, select the triangle to see the replay. 'Swipe here to paint' indicates that you can add to your image, if you wish. (Whilst it is interesting to see how the initial apple picture was built up in stages, there are no instructions describing *how* it was created, so it is of limited use.)

Select the small cross at the top right of the screen and a sign will appear saying New Painting, as well as some numbers – usually 768×1024 – indicating the number of pixels in the picture. Also there is a curled arrow that enables you to change the format of your picture from portrait to landscape. Now select Create and this will produce a blank screen ready for a picture. Pinch in, to bring the paper slightly away from the edges of the screen.

EXPLANATION OF BRUSHES SCREEN

COLOUR SELECTION
The Colour Selection icon is in the bottom left corner of the screen. Select the tiny rectangle. The large circle gives a choice of main colour and the large square gives the tone of your chosen colour. Both choices can be altered by moving the small white circle within the shape. Below the large circle and the square is a slider, for altering the opacity of the colour. Beneath this is a series of small squares, which represent a colour palette, where you can store and use particular colours. In fact it would be possible to make a whole palette before starting and then work from it. To put a colour into the palette, simply select that colour in the box in the left-hand corner and then tap on one of the empty squares where the colour will be stored. To use it, simply select it with your stylus. When the palette is full, it is possible to make the space available again by simply tapping on the square next to the colour you want to eliminate, right or left, and then sliding the colour you want to keep over the one you want to eliminate. A space will then become free.

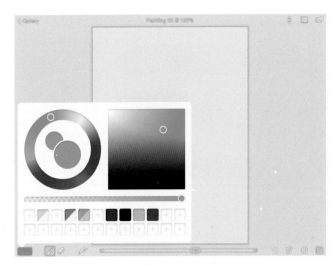

Fig. 11.3 **Colour selection table.**

BRUSH ICON
Next to the Colour Selection rectangle there a little Brush icon enclosed within a square. After you have used the Eraser, which is the next icon to the right, tapping on this icon will return you to the Brush.

ERASER
The size of the Eraser is controlled by the slider that controls the Brush size. It is excellent for making tiny rubbings out.

BRUSH SELECTION
This icon enables you to choose and define the characteristics of your brushes. In this app you make your own brushes. Different types of brushes can be stored here to use again and again.

LONG SLIDER
This will control the size of the Brush.

UNDO/REDO BUTTON
To erase your last marks/put them back.

LAYER OPTIONS/LAYERS
These work in much the same way as the ArtRage Layers.

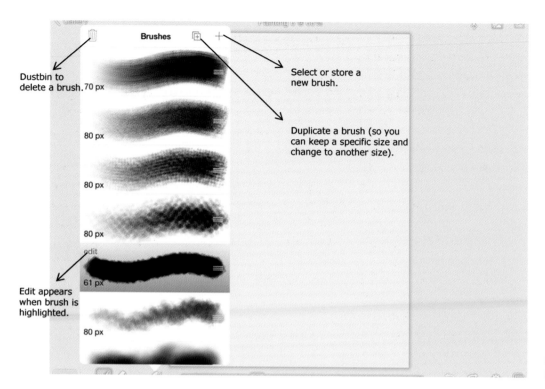

Dustbin to delete a brush.

Select or store a new brush.

Duplicate a brush (so you can keep a specific size and change to another size).

Edit appears when brush is highlighted.

70 px

80 px

80 px

80 px

edit

61 px

80 px

Fig. 11.4
First Brushes screen.

Fig. 11.5 Exercise with different size marks.

Fig. 11.6 Second Brushes screen.

DRAWING WITH BRUSHES XP

One of the differences between the ArtRage app and Brushes XP is that you make your own brushes.

BRUSH SELECTION

To select one or more brushes use the table illustrated above (Fig. 11.4) to make and store them. They can be used at will, changing their size when necessary rather than making a new brush each time.

When first pressing the squiggly Brush Selection icon you will be faced with a screen displaying a number of Brush types you can use. The numbers at the side, e.g. 80 px, represents the size of the Brush, as indicated on the slider at the bottom of the screen. Tapping on a particular Brush will highlight it in blue. Use that Brush and change the size as you work (See Fig. 11.5.). Then tap on the cross for a new Brush and see how this one with its new size is stored in the original Brush table. If you want to refine your Brushes further, select Edit. This option is evident, but in quite small letters when a brush is highlighted in blue.

Selecting Edit produces the screen shown in Fig. 11.6.

Using the edit option, scroll to the rectangle shape seen in the illustration. At the top of the drop-down table is the type of mark that the brush will make. The characteristics of it can

be changed by altering the sliders further down the table. Try moving the sliders now and see how the mark changes (Intensity is particularly effective). Having investigated the sliders, go back to the top and keeping the same settings, scroll through the different brush shapes. Entirely different marks appear at the top of the screen.

STORING, DUPLICATING, MOVING AND DELETING SETTINGS

Select the Brushes icon at the bottom of the screen again; then, on the drop-down table, select the cross in the top right-hand corner. The mark created by this setting is then automatically stored (with its relevant opacity and size) in the table. To duplicate the marks, select the tiny cross in the square. To move the marks up and down the table, select the little lines on the right of the rectangle and slide. To get rid of a brush, highlight it and then select the dustbin icon.

Although this process is rather complicated initially, being able to select your own brushes is an important part of the Brushes XP app.

After opening Brushes XP and having selected Create, you will then need to put the stylus on the wiggly Brush icon at the bottom of the screen. This will immediately give a series of ready-made brush options that you can use.

However, if you want to be very specific about the kind of brush you need then you should select Edit. This will be written alongside one of the brushes that is highlighted in blue. Scroll to the end of the different Brush options and you will see a rectangular Brush shape. This Brush has only one attribute: Width. Just try scrolling on width to see how the basic shape changes. Under Width you have a further series of five different options. Select Width 50, Intensity 100, and set all the other options at 0. Select black colour. Now you can make marks on the screen.

Draw marks of different sizes, moving the slider at the bottom of the screen. The numbers on the slider allow you to note the sizes of marks you like best. Practise this a few times, making some really big marks next to some very small ones and save some of them into the drop-down menu.

To start again with new sheet of paper, select Gallery in the top left corner. The painting that has just been completed will be saved automatically into the Gallery; to start again, press the cross in the top right-hand corner and then select Create.

To delete a painting from the Gallery, choose Select in the top left corner and then select the painting you wish to delete. More than one painting can be selected and the small blue tick will appear on each painting. Now select the dustbin in the top right-hand corner and another sign will appear confirming that you really wish to delete this painting. When you have confirmed the deletion, select Done.

COLOUR PRACTICE USING THE OPACITY SLIDER

Select the cross at the top right-hand corner to create a new piece of paper. Pinch in.

Select a vibrant colour from the colour chart and make some simple marks using the long thin slider to vary the opacity. Keep the settings the same, with the same Width and Intensity and 0 for everything else. You need to keep returning to the colour selection chart after each stroke to move the slider. Notice that when the colour has a low opacity, the colours overlay each other in a pleasing way.

Do this again, this time using different colours with different opacities. Try to make a pleasing design over the screen. Practise moving the little white circle on the main square to make eight different tones.

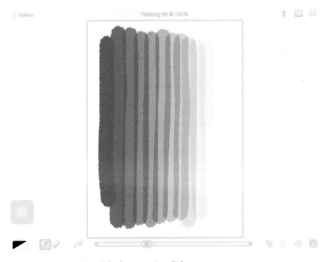

Fig. 11.7 **Practise with the opacity slider.**

A simple picture with Brushes XP

Create a new sheet of paper to work on. Selecting the brush shapes by editing, scroll one shape back from the rectangle shape to the star shape. The first heading under the star is Number of Points. Scroll along to select how many points you would like on your star. Keep the intensity at 100, Angle 0, and experiment with the spacing. Here you need to make some choices. Do you want your stars close together or far apart? Try Jitter at 0, and experiment with Scatter (Dynamic Angle, Dynamic Weight, Dynamic Intensity all 0). Tap the screen to get rid of the table and now make a starry sky. Vary the tone of your star shapes with the colour slider and the actual size of your stars with the slider at the bottom of the screen. Remember that if there is something you do not like simply select the Undo button.

At this stage just experiment with this app. Scroll through all the different shapes on offer and, on a new sheet of paper each time, try to see what each brush does. You will find the one you like best.

Just as with ArtRage, you need lots of practice to get to grips with this app (although in many ways it is easier than ArtRage). Be experimental with the brushes selection; there are some wonderful textures you can use in splendid ways.

Fig. 11.8 Now you have made your first real picture with Brushes XP, it might look like this.

USING LAYERS IN BRUSHES XP

Using layers is like painting on sheets of clear plastic to build up a picture. Layers can vary in transparency, can be hidden, moved up and down the pile, or deleted. They can be used for an initial pencil sketch, for filling in backgrounds, for collage, for transparent washes and glazes, and will allow lights on top. They also enable highlights to be put on top of dark areas.

Note: if you have come straight to this section without reading the ArtRage chapters, you are advised to read Chapter 10, where ArtRage Layers are described in detail. Many of the features of Layers in Brushes XP are similar to those in ArtRage, for example sliding the layers up and down, closing the eye, and locking a layer.

LAYER OPTIONS
Select the tiny cog wheel at the bottom right of the screen to reveal the layer options.

Clear Layer
This is self-explanatory.

Fill Layer
This performs exactly the same as the Fill Tool in ArtRage and will flood a layer with the chosen colour.

Saturate
This will remove all colour from the chosen layer.

Fig. 11.9 This illustrates the various options that are available.

Invert Colour

This will change the colour to the other side of the colour spectrum.

Colour Balance

Selecting this will produce a chart on the screen that offers the opportunity to change the colour balance in a picture. Move the slider around till you get the effect that you want. When you are happy, select Accept, and it will then go into your layer.

Hue and Saturation

Another opportunity to try out different subtleties of colour in your image.

Flip Horizontally, Flip Vertically

These headings are self-explanatory.

Transform

This enables the whole image to be moved around, which sometimes gives a more pleasing effect. If you want to transform just one element of the picture, draw this individually on a separate layer.

This lovely image, done with Brushes XP, is of a statue in the Trinity Chapel of Salisbury Cathedral. It was done using three layers. The thin outline of the composition was done on Layer 1. Layer 2 provided the surface for general colour, the detail and the highlights. Layer 3 was used for the white stalks. Careful observation and limited colour make it a successful image.

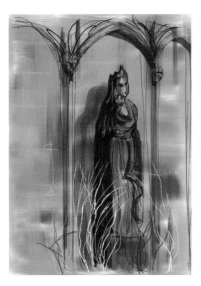

Fig. 11.10 *Madonna and Child* **by Margaret Gill.**

Select the cross (top right) for a new piece of paper. Select Create, and pinch in. Select a dark colour to fill the screen. Select Layer Options (second icon from the right at the bottom). Then select Fill Layer (second option). The screen should change to your chosen colour (Fig. 11.11).

Select the plus sign at the top of the Layers table to create a new layer, Layer 2. Close the eye of Layer 1 by selecting it, then tap the screen to remove the table.

On the blank screen, Layer 2, which must be highlighted in blue, draw freely with a dark colour using any brush. I have selected a brush that gives a line. The Layers box at the bottom right should show the figure 2.

Tap on it and the Layers table will appear again.

Open the eye on Layer 1. You will now see two layers. Now move the layers about, so that Layer 1 becomes Layer 2: select and hold the parallel lines on the right-hand side of the image and slide Layer 1 upwards so that it becomes Layer 2 (Fig. 11.12).

Fig. 11.11
Press on 1 (bottom right of the screen) to show the layers table. You should have a screen that looks like this.

Fig. 11.12
Showing the new position of Layer 1.

Now, making sure that Layer 2 is highlighted, go to the Opacity slider at the bottom of the Layer table. Move this about to change the Opacity of Layer 2. See how the image on Layer 1 gradually appears from under the opaque Layer 2 as the Opacity changes.

Keeping Layer 2 highlighted, select the Eraser and use it to rub out part of that layer to expose Layer 1.

When you are happy with the resulting image, select Gallery to save your layer picture.

This exercise has used a few options for Layers. One possibility is to start with a sketch and keep this layer at the top as you are painting; you can also use photos to build up a collage. Or you could use transparent layers as you would use washes or glazes in watercolour, but on the iPad the paint will not get muddy and you can put the highlights in.

Fig. 11.13 Image appearing from below layer 2.

Fig. 11.14 The picture with parts rubbed out exposing layer 1.

Fig. 11.15 *Heather Hillside* **by Juliet Jones.**

This picture was created by Juliet Jones using Brushes 3. She has been working almost exclusively with Brushes and sent me this lovely image for the book. Her quite comprehensive account of how she made it is included here because it illustrates an excellent approach to any iPad work.

I do a lot of paintings of mountainous areas in other media, so decided to stick to a motif I'm familiar with for this exercise. I had an image in my head: portrait format, high horizon, jumbled heather and rocks with foreground out of focus. So I started with swooping, curving shapes in purple, russet and mauve varying occasionally in intensity, using the large round brush at 70px, overlapping some shapes and colours but also leaving patches of unpainted space. When I was happy with the arrangement of forms, I drew the distant rocks in pale violet and the heather stems/flowers and rocks in the middle distance, in purple, with the same brush at 10px. I touched in some colour on the rocks on the horizon and swiped the same colour across the sky.

Then I added further line drawing using the flat brush at 5px, for foreground detail, picking up colours from the

painting with the stylus. (In fact I used the stylus throughout as I like the feeling of holding a 'brush' or 'pencil'.) I kept looking at the composition from a little distance away (i.e. at arm's length) as I painted, and towards the end I erased a couple more light areas on the middle ground rocks and finally added some stronger tones using a brush at 22px. By the time I decided I'd finished, I realized I'd been painting for about two hours … but I enjoyed it!

Overview of Procreate

Procreate is another app worth consideration. It is not as easy to use as Zen Brush and, like ArtRage, it takes some time to get to know. However, once you have mastered ArtRage, Procreate will come more easily to you, as many of the functions are similar.

After downloading Procreate from the app store and onto your initial screen, select the icon to bring it up on your iPad. This will take you directly into Gallery.

(*Note*: the aim here is to present just an overview; if you want to go into Procreate in great detail you can download the handbook, which will describe all its functions in great detail. For example, the Procreate app has facility enabling you to design your own brushes – a process which is exciting but too complex to describe here.)

EXPLANATION OF THE SCREEN AND ICONS

The Gallery (icon in the top left corner) is where pictures are stored. As with ArtRage and Brushes XP, when a picture is finished it is saved directly into Gallery. You can recover an image from the Gallery and continue to work on it. To delete a picture from the Gallery, select the image and swipe to the left. This presents 3 options: delete, duplicate, or share. The plus sign in the top right-hand corner returns to the start, ready for a new picture.

The second icon is a picture of a spanner; this will bring up an Actions menu with many possibilities. Here you can import and export pictures, and flip and copy them. You can

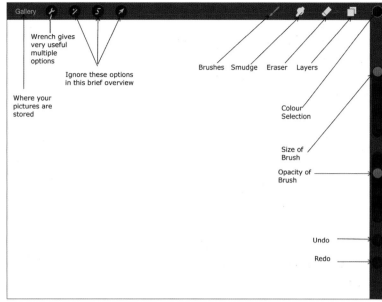

Fig. 11.16 The Procreate screen and its icons.

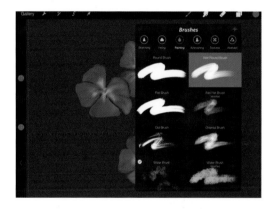

Fig. 11.17 Screen showing Brush Selection.

also save directly into the photo app and email a painting to a friend, so it is a very useful icon.

The next three icons along the top edge (Filters, Precision Slider, and Arrow) are beyond the scope of this book.

The next icon along the top is a paintbrush. Select this to see the drop-down menu of Brushes. There are six different icons at the top of the drop-down table indicating the types of brush available: Sketching, Inking, Painting, Airbrushing, Textures, and Abstract.

Underneath there is a further selection of possibilities of how your choice of brush might perform. The choice is different for each individual brush but they are all worth experimenting with, especially Textures and Abstract. The size of the brush and the opacity are controlled by the sliders at the side.

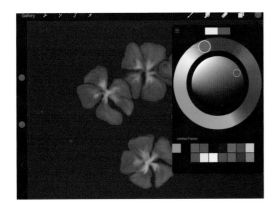

On the edge of the screen (usually on the right, but sometimes on the left as well) you will see two important sliders: the top one changes the size of the Brush; the lower one changes the Colour Opacity. Some practice will be needed to see how much they need to be moved to make a real difference.

Further down the side of the screen are Undo and Redo.

Fig. 11.18 Screen showing colour selection circle.

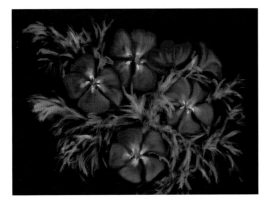

Fig. 11.19 *Garden Flowers* by Mary Langham. Example of a picture drawn with Procreate.

The next icon is the Smudge icon. Pressing on this will smudge the colours together in a similar way to the Palette Knife in ArtRage.

The Eraser icon is next; its size and opacity can be controlled by the sliders at the side.

The Layers function is represented by the two overlapping squares. When you tap on this the first layer will appear. Layers work in a similar way to Brushes XP and ArtRage. To make a coloured background to work on, select the Layers icon and underneath Layer 1 you will see the heading Background. Select the white rectangle and the colour wheel will appear; select the colour in the tonal area and press on it with your stylus. Your background colour will then appear on the paper. To add a new layer, click on the plus sign in the Layers drop-down menu. When the layer is active it has a blue background; as with the other apps you can only make marks on that layer when it is active.

The circle in the top right-hand corner of the screen is Colour Selection. Tapping on this icon brings up the large circle, as shown below. The outer circle allows you to choose the basic colour while the inner circle allows you to select the tone. Underneath the circle is a row of colours where you can store your favourites.

EXERCISE 1
Making marks with Procreate

Select Gallery, and tap the cross in the top right-hand corner. From the choice of surfaces, choose Retina. Pinch the screen to bring the paper in. Select Brush choose Painting and Round Brush. Select a Colour and make some free marks on the picture surface, experimenting with the size and opacity of the strokes.

EXERCISE 2
Drawing a face

Select Gallery to start a new picture. Choose Retina. Select Brushes, and Sketching. Using Artist's Crayon, roughly sketch a face on your paper surface.

EXERCISE 3
An imaginary landscape

Select Gallery to start a new picture and select the cross (top right-hand corner) to choose your picture surface. This time, select Square.

Select Brushes: Sketching, and choose 6B Pencil to draw with, on maximum size and opacity. Roughly draw an imaginary landscape.

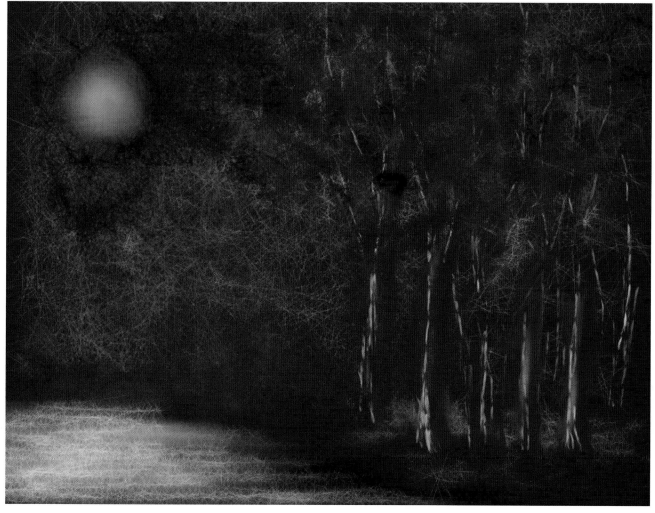

Fig. 11.20 *Moonlight* by Mary Langham.

EXAMPLE OF A LANDSCAPE PICTURE USING PROCREATE

The illustration above shows a more complex picture done by Mary.

She writes:

I did not really start out with any particular idea in mind but was just messing about with this app to see what it would do. I first made a background colour of brown. From the Painting Brush Selection I chose the Round Brush and painted the blue in the sky. After that I used the Water Brush to paint the moon. Staying with this brush selection I put in the water and added a bit of Smudge. To get some of the highlights and sparkle on the water I used the Abstract Brush and selected Spicule, on a very small size. The tree trunks were put in with the Wet Round Brush. Highlights on the tree were added with the Old Brush. Leaves on the tree were made with the Abstract Brush Spicule with a brush about 75% in size and highlights were added with white on a smaller size. The ground was done with the same brush and some of the shadows were smudged. In the end I was unexpectedly pleased with what I had produced.

Procreate is an extremely interesting app and has some completely different features to ArtRage or Brushes, so there is much to experiment with.

Note: despite including overviews of two different apps in addition to ArtRage I would advise you not to spread your net too widely in the first instance, but rather get to know one app really well. This overview here is just to show how you might progress after mastering ArtRage.

Chapter 12

Projects & profiles

Paint something every day.

DAVID HOCKNEY

This chapter outlines three projects, each developing a particular theme or idea. They offer an opportunity to practise what you have learnt through the book, and this will increase your skill and confidence. You could also choose your own projects, using some of these methods.

Fig. 12.0 *The Warmth of Egypt*. This picture was actually done in Egypt. The wealth of rich colours and an abundance of pattern were the driving forces in making the image. This is just one of a series of pictures I made.

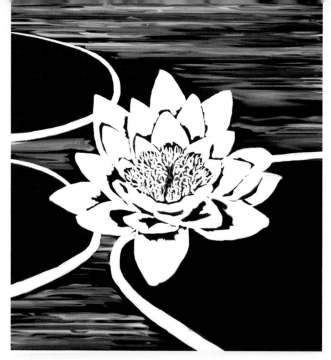

Fig. 12.1 The first drawing was done on the iPad from a photograph of the pond. Angela chose Basic Paper to work on and the paper was coloured black on the initial screen.

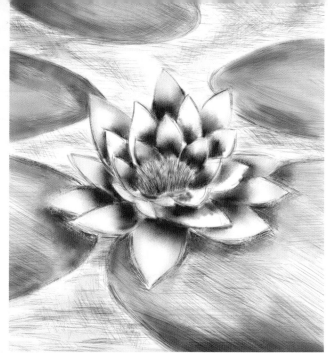

Fig. 12.2 This picture was made by choosing White Paper Basic and importing the original drawing of the lily into the tracing icon.

Working with a single image

This set of pictures shows how it is possible to develop a single drawing – here a simple waterlily in a garden pond – in many different ways. The basic composition remained the same and the image was traced for each version. Angela Whitehead has provided all four images for this project.

Wax Crayon Tool in white, Size 25%, Pressure 50%, Softness 0%.

The white parts of the petals were drawn, with spaces left in between them. Stamens were drawn using the same tool, Size 15%, Pressure 15%.

At this pressure the lines for the stamens were grey. On top of the pale stamens, more stamens were drawn with the same tool, Size 5%, Pressure 70%. The darker stamens provided an effective contrasting texture alongside the lighter ones.

Leaf positions were chosen, thinking about composition and the negative shapes within the picture. The leaves were drawn in with the same tool, Size 20%, Pressure 30%, Softness 0%. Then the Pressure was increased to 70% to draw over the edges of the leaves.

Horizontal lines were drawn between the leaves to start the water effect. They were then modified with Hard Out Smear and the Palette Knife, Size 50%, Pressure 100%, Smudge 20%.

For the next image, the Pencil Tool was selected, Preset Soft Tip, Size 5%, Pressure 15%, Softness 100%, Tilt angle 0%, Precise off.

A pink colour was selected for drawing around the petal shapes and for the leaves. Shading was added to the base of the petal, still using the Pencil. When this was complete the Palette Knife was used to blur the shading, Preset Tiny Frost, Size 30%, Pressure 70%, Falloff 50%, all other settings default.

Then, with Pencil Tool, Size 10%, Pressure 20%, Softness 100%, the grey outlines of the leaves were drawn and shaded in, making them quite strong under the petals. Some grey shading was used in the water too. Next the stamens were drawn with the Pencil Tool using different pressures to give a texture. Some of the shading on the leaves was blended with the Palette Knife, small Size, Preset Blurred Frosting.

At this point, on an enlarged screen, the Fill Tool was chosen to tint the petals. A darker pink colour was selected. Fill Tool settings were 70% Opacity, Spread 10%. (Remember that the Fill Tool has to be used very carefully, otherwise the fill will spread all over the picture. There is always the Undo button if this last operation goes wrong.)

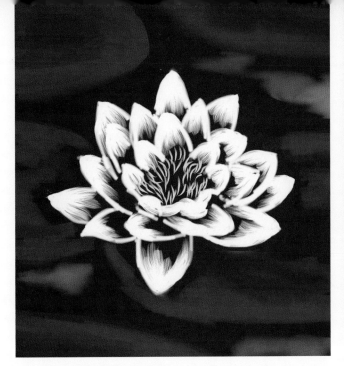

Fig. 12.3 The basic blue paper was coloured on the initial screen. The lily image was imported and traced over with the Oil Brush.

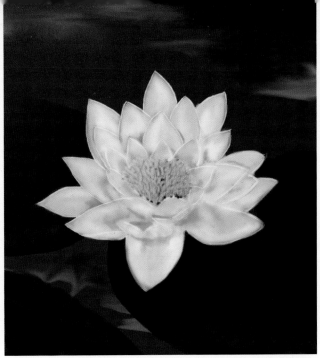

Fig. 12.4 Basic White Paper was chosen and coloured blue on the initial screen. The lily image was imported into the tracing option and traced as before.

For Fig. 12.3, the Oil Brush was used. Preset Normal Round, Size 10%, Thinners 25%, Pressure 50%, Loading 50%.

After the initial drawing the texture in the petals was painted in with the Oil Brush, Preset Dry Clumps, Size 50%, Pressure 50%, Loading 5%, Thinners 25%.

The stamens were then painted, still with the same Oil Brush and Preset but with the Size reduced to 10%, Pressure 50%, Loading 5%, Thinners 25%.

The Airbrush Tool was chosen to do the background. Colours were carefully selected to tone in with the flower. Airbrush Preset Big and Subtle, Size 65%, Pressure 25%, Opacity 45%.

Hints of yellow and blue were made to represent the water. The Colour Sampler tool was used to get the background colour into the colour pod and then on the colour wheel. Just moving the colours slightly to select a darker tone, leaf shapes were drawn with the Oil Brush, Preset Normal Round, Size 50%, Pressure 50%, Thinners 100%, Loading 50%.

The yellow patches were blurred slightly, using the Palette Knife, to resemble reflections in the water.

The Airbrush was used for tracing, Size 20%, Pressure 85%, Opacity 60%, Tilt Angle 0%, Taper Length 0%, Autoflow on.

The image was carefully traced and then the eye was closed to leave a pale outline.

Still using the Airbrush, Size 40%, Pressure 60%, Opacity 80%, various shades of pink were used, leaving the basic pink colour in the outer ring but gently changing the tone. The petal shapes were magically built up in this way, changing the Size, Pressure and Opacity.

When the petals were complete, a yellow colour was added to the centre: Size 40%, Pressure 60%, Opacity 70%. This appeared as a blob as stamens were to be added later. Next the petals were edged in a very pale pink, Size 5%, Pressure 85%, Opacity 70%.

Still using the Airbrush a dark green colour was chosen and the leaves were drawn and filled in, Size 50%, Pressure 90%, Opacity 85%. Horizontal pink and green lines were drawn to represent the water (using more green than pink). The Palette Knife was then used on Preset Hard Out Smear to create the reflections.

The stamens were drawn in a pale yellow, still using the Airbrush, Size 15%, Pressure 85%, Opacity 80%. The Airbrush was then changed to a very small size and some deeper yellow and some dark green stamens were added to give more texture to the centre of the lily. Finally, even more stamens were added in yellow, with the Pencil, Size 5%, to produce the final version.

Fig. 12.5 Malevich copy by Elaine Fear.

PROJECT 2
The head in modern art

This project represents a different kind of challenge. I have always believed that one way to advance your skills as an artist is to look at recognized pieces of work by famous artists and see how they have dealt with colour and composition. This study of recognized works should prompt new ideas in your own work. And so it is with the iPad: copying a piece of work could suggest new ways of using tools and effects that can be created by reproducing a well-known picture.

The head has been a universal theme in art throughout the ages and has been used by artists for many different reasons. Consider the portraits by Andy Warhol (they would be fun to copy, but quite demanding) and those by Lucien Freud, in a totally contrasting style. Both artists produced highly prized works of art, each expressing a different emphasis on the face and its features. Andy Warhol reflected his personal take on the modern world; Lucien Freud was much more concerned with reality and the innermost character of his sitter.

In a class exercise students were in fact to choose a modern portrait (painted since 1900) that they admired, and, rather than using the reference icon on the iPad to copy the picture, to bring in an actual reproduction of the picture in postcard form or similar. It is much easier to see the actual brush

Fig. 12.6 Modigliani copy by Janet Phillips.

strokes in a larger-scale reproduction. Each student was asked to write about why they had chosen that particular picture and what it meant to them. This was to introduce a critical aspect of the work that would be useful in assessing their own iPad creations in the future.

All the pictures of heads reproduced here represent the copies that the students made from the originals.

Elaine chose a self-portrait of the Russian artist, Kazimir Malevich. She writes: 'I went to the Malevich exhibition at the Tate gallery and was fascinated by the variety of styles the artist went through on his journey to his most famous works. I loved this self-portrait which seemed so direct and modern.'

Elaine chose Paper Fine to work on and a square format, 1024×1024. The picture was done in three layers: Layer 1 for the background, Layer 2 for the detail, and Layer 3 for extra background and more detail on the coat. The background colour on Layer 1 was done with the Fill Tool. Layer 2 was completed mainly with the Inking Pen on low Opacity. The screen was pinched and expanded to 300% for details on the

Fig. 12.7 Jawlensky copy by Judith Fletcher.

face and eyes. The third layer was added to improve the colour on the jacket and some shading. Finally more detail was added to the background on Layer 1.

This very different picture (Fig. 12.6) was chosen by Janet and is more delicate and gentle in nature. Modigliani painted portraits throughout his short life and this picture is typical of his work.

Janet writes, 'I chose this picture because I like the way Modigliani distorts the image but still retains a likeness.'

Rough paper was chosen to work on and she used two layers. The actual portrait was done on Layer 1 and the background on Layer 2, which was subsequently moved to the bottom of the pile. The outline of the figure was drawn with the Chalk Tool in a small size; then the figure was gradually built up, using the Chalk Tool and the Palette Knife. The Oil Brush and Palette Knife on Preset Harsh Chaos were used for the background.

For this exercise Judith, who also drew the portrait of her husband in Chapter 7, chose the picture *Helene with a Blue Turban* by Jawlensky. Judith's daring use of bold colour in her portrait is echoed here in her choice of picture.

She writes, 'I chose this picture because I liked her bold sideways glance and the rich colours. These colours actually surprise you, the green in the eyes, the yellow in the neck and the blue on the hair.'

Her version of the picture was made on fine canvas. No grain and no layers were used. Initially she drew the outline with a small Oil Brush, and after that the outline was filled in, gradually building up colour, still using the Oil Brush, with Preset Thick Gloss. Sometimes Insta-Dry was used but at other times it was switched off, so that the colours blended.

It would be interesting to take a standard picture from a newspaper and see if the Jawlensky colours could be freely applied to the image.

Fig. 12.8 These two illustrations show sketches I made on the iPad looking at windows, thinking that these might provide a starting point for some imaginative compositions.

Fig. 12.9 *The Warmth of Egypt.*

PROJECT 3
Buildings

Buildings are all around us, wherever we are in the world. They provide a wide range of textures, shapes and forms to inspire us – for example, think of all of the different shapes that are provided by windows. Many of us look out on interesting sky-lines provided by the shapes of buildings silhouetted against the sky.

The two illustrations above (Fig. 12.8) show sketches I made on the iPad looking at windows, thinking that these might provide a starting point for some imaginative compositions.

Following on from the idea that there is a wealth of poten-tially creative material in the design and shapes of buildings, iPad students were asked to bring in a photo of a building to work from and, using any tools they liked, to transform this picture into an iPad image.

The wonderfully colourful Egyptian landscape inspired Fig. 12.9. I chose Concrete Paper which has a very interesting texture and using the Chalk tool and the Palette Knife made an interesting background to work on. Then using the Pencil, I drew the details of the architecture over the textured back-ground. The picture was done on just one layer.

Fig. 12.10 *Christmas at Hambleden Church* by Judith Fletcher.

Fig. 12.11 *Local Skyline* by Janet Phillips.

Judith used layers to make this picture. She describes her method below:

> First I imported a photograph, taken in the summer, into the Tracing icon and reduced its Opacity to 50%. Then I opened a new Layer and drew over the photo, changing it to an imagined winter scene.

> I used Inking Pen for the line work and the Fill Tool to colour the areas of flat colour.

> Finally I used the Eraser (Preset Instant Erase, Size 1% and 3%) to draw over the coloured areas, adding tree outlines and snowflakes.

Janet chose a Canvas surface to work on and kept the base colour white. She decided she would make use of layers to interpret this picture of the skyline of her local town. Initially the drawings of the buildings in the foreground were done with the Chalk Tool on maximum pressure but she deliberately chose a limited colour palette. The distant buildings were sketched in with the Pencil on maximum pressure and tilt angle.

After that a second layer was selected for the background which was completed using the Roller on the biggest size.

Third and fourth layers were added, still using the Roller and drawing diagonal lines in blue and orange all over the surface. Then parts of the lines were deleted, with the Eraser set on its biggest size and maximum pressure.

The final top layer was drawn with the Pencil Tool to add some dark lines and also to emphasize some of the shapes in the buildings.

Although the picture is abstract, it still conforms to the convention of distance by using receding colour and shape; the use of complementary colours has definitely helped to give the picture coherence.

Fig. 12.12 *Sagrada Familia* by Elaine Fear.

Elaine chose the iconic image of the Sagrada Familia in Barcelona for her interpretation. She decided to work on Basic Paper and kept the surface white. The picture was made with three layers: Layer 1 was used for the sky, Layer 2 for the shading, and Layer 3 for the outline.

To start with the sky colour was made on Layer 1 using the Fill Tool. Then the photograph of the building was fed into the Tracing icon and the basic outline was drawn. The photographic image was cleared after drawing the outline. On Layer 2, the basic structure of the tower was made using the Roller on a small size, Preset Speckled Line. For Layer 3 the photograph was reintroduced to provide the detail of the image and this was drawn with the Inking Pen. Finally, the photographic Image was cleared from the WPPP

Profiles of some iPad artists

This section presents some profiles of artists and describes how they use the iPad in very different ways. From the selection of work shown you can see that each artist has a definite personal style running through their work.

JANET PHILLIPS

Janet has experimented with most media and now paints mostly in acrylics and acrylic inks. She is also a photographer and likes to play with 'creative' photography in her work. Having been a lifelong fan of David Hockney, she bought an iPad after visiting his exhibition in London in 2012 and soon fell in love with it. As there seemed to be so much to learn, she founded a small iPad art group to provide mutual support and inspiration among its members.

The iPad has been a revelation for her. She now produces unique artwork quickly and easily, and uses it to shape ideas and compositions. She has found it extremely useful to photograph paintings in progress and to test ideas for a painting's development before returning to the paints.

Some of Janet's images are shown here. In all three pictures she has used layers.

Fig. 12.13 *Kitchen Still Life*.

Fig. 12.14
Birthday Tulips.

Janet used four layers to make this still life (Fig. 12.13)with the Oil Brush, Chalk and Roller Tools. All the strokes mirror beautifully the direction of the surface of the objects.

Janet created this vibrant picture of tulips on three layers using mainly the Watercolour Brush and Chalk Tools. On Layer 1 she painted the tulip leaves and the flowers. The foreground tulips were made on Layer 2 so they could overlap the first ones without difficulty. Finally, Layer 3 was added, moved to the bottom and the background painted with Watercolour (large brush) and blended with the Palette Knife.

This image combines photos of a peace lily and a circular wall hanging. The peace lily was imported into a layer and adjusted to fill the canvas. The circular wall hanging was then imported onto another layer on top and the surroundings removed with the eraser. The peace lily layer was then duplicated and partially erased to reveal the wall hanging underneath. Another layer was added with the Fill Tool to make a red background. On the first lily layer, she used a Soft Eraser to delete some of the space next to the round shape so that the red background showed through. Finally, Janet added a fifth layer and drew thin lines with a red Inking Pen to define and unify the picture.

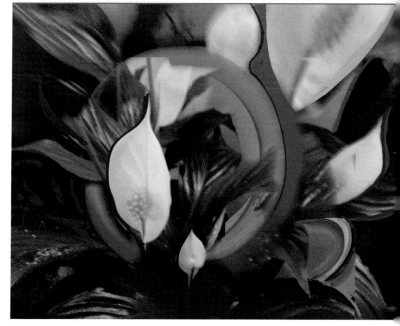

Fig. 12.15 Composition.

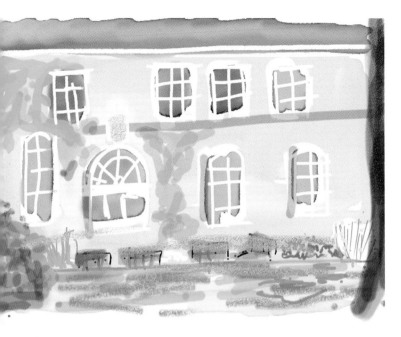

Fig. 12.16 First outdoor painting.

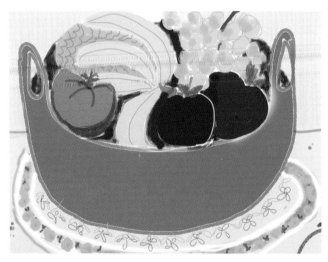

Fig. 12.17 *Fruit Bowl.*

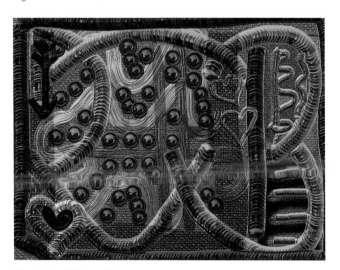

Fig. 12.18 Tube tool fun.

ANGELA ROSE

This artist is over 75 years old; her inclusion here illustrates the fact that you are never too old to take up drawing and painting on the iPad.

Angela joined a course I was teaching at Marlborough College. She had bought a mini iPad, after seeing her friend using one. She was intrigued by all the possibilities that this tiny tablet had to offer but felt that some basic instruction was necessary. Unlike some of the others profiled here, Angela did not have an IT background but managed some very presentable images in a short time, illustrating that the iPad can be used on a variety of levels.

Shown here are some of the images that Angela produced on the Marlborough course.

Sitting in the shade Angela painted this image of a building facade (Fig. 12.16) with a mixture of tools including the Watercolour Brush, Inking Pen and Chalk.

This wonderfully colourful still life (Fig. 12.17) has a directness that comes from drawing with the objects in front of you. This image was made on coloured ground and has a marvellous abstract quality to it, as it sits so perfectly within the rectangle. Basic shapes were drawn with the Chalk Tool and further detail was added with the Inking Pen.

Next Angela has used the Tube Tool, working on Canvas Basic and with the Metallic Function at 50%. The picture (Fig. 12.18) has lovely colour harmony and good design. The limited range of colour has really helped the whole image appear as a unified whole, even though it is made up of many small elements.

MARGARET GILL

Margaret spent the majority of her working life as a doctor
and only pursued art training much later. Her mainstream
work in the visual arts has been drawing, painting and
print-making, and the knowledge of these disciplines has fed
into her work with the iPad. She has tried many apps, but has
found ArtRage and Brushes to be the most comprehensively
useful. The facility to draw different parts of the picture
in layers and then import and re-size them is particularly
useful. Also she feels that the iPad really comes into its own
when planning a composition on paper or canvas before the
paint is applied to the surface, as it is so easy to save all the
sketches and then select the best.

Here are some of her images.

Margaret was inspired by the large tapestry in Coventry
Cathedral designed by Graham Sutherland. She grew up in
Coventry and was very familiar with these strong images.
This picture (Fig. 12.19) was created using four layers. Layer
1 had a succession of colour washes on it. Broad details were
put on Layer 2; Layers 3 and 4 were used to fine-tune the
image.

This lovely image of a sleeping child (Fig. 12.20) was made
with the Brushes app. After some careful drawing of the
shape of the head and body, further details were added with a
very small brush size on an enlarged screen.

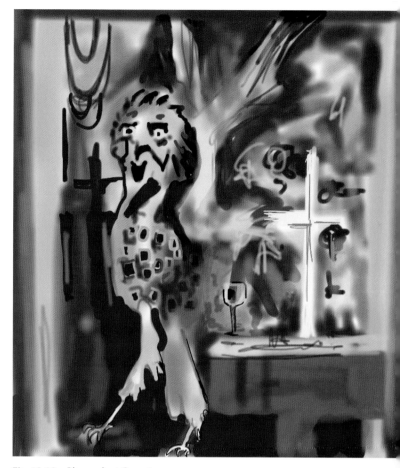

Fig. 12.19 *Rhapsody at Coventry.*

Fig. 12.20
Sleeping Baby.

Fig. 12.21 *Spring.*

ANGELA WHITEHEAD

Angela has provided many of the illustrations for this book; she particularly likes drawing and painting flowers. Although now an accomplished artist, she started using the iPad just 18 months ago.

Having seen a friend use an iPad she was keen to have one; she says it now has encouraged her to be more adventurous with her general art work. The iPad enables her to exploit colour more and investigate ways of developing an idea. She loves the ability to save versions of pictures (which is a very liberating experience), knowing that it is easy to return to earlier versions. Fine, detailed work is of particular pleasure to her and she has found, by using low Pressure settings for the Pencil Airbrush or Chalk, that it is possible to build up a soft image, which suits her paintings particularly well.

Angela created this image to accompany her profile; here she describes how she did it:

I started with blue paper coloured on the initial screen. Then, using the Chalk Tool on low Pressure I blocked in the daffodil shapes, using the Eraser for shaping the edges neatly. After that, still using the Chalk Tool on low Pressure, I shaded the petals of the flower and used some occasional blurring on a very small size. Next I drew the campanulas with the Chalk Tool in shades of blue and pink. Again I used the Eraser to shape the edges and subsequently used Hard Out Smear to blend the colours nicely. The same tool was used for the leaves and stems. Finally the veins of the leaves were put in with the Pencil Tool.

I am not a teacher, only a fellow traveller of whom you asked the way. I pointed ahead – ahead of myself as well as you.

GEORGE BERNARD SHAW

Glossary

Some of the technical terms used in this book are defined below.

App
Abbreviation for 'application', a program loaded onto your iPad which allows you to access certain information or facilities, for example, music videos. There are thousands of apps that can be accessed through the App Store (found on your main screen). The ArtRage app allows you to draw or paint.

Importing an image
This refers to accessing the image from outside the app, for example, using ArtRage to obtain a photo from the Internet.

Layers
Using a layering technique allows you to add additional elements to your picture. It is like creating an image using transparent sheets of film; each layer is independent of the others. The layers will be merged together (i.e. placed one on top of the other) when the picture is saved.

Megabytes and gigabytes
These represent units of memory (see below) which come with the iPad. The more megabytes, the more storage capacity is in the iPad. 1000 megabytes = 1 gigabytes

Memory
This represents the ability of the iPad to store information, not only for iPad images in the gallery but also for storing photos, videos etc., all of which are then available at the touch of a button. If you think you will want to store a large amount of information you should buy an iPad with a lot of memory (gigabytes).

Pinch the screen
This refers to bringing the sides of the paper in from the outer edges of the screen so that you can paint right up to edge of the picture. This is achieved by putting the thumb and another finger on the screen and pulling them together, moving the paper into the centre of the screen.

Pixels
These very tiny dots represent the smallest units from which the picture is made up.

Save
This function allows you to save the image you have made into the gallery within the iPad so that you can look at it at a later date.

Screen shot
At some time you may want to take a copy of whatever is on the screen, e.g. when you are in the process of making an image. To take a screen shot, select the 'Home' button on the left-hand side of the screen with one finger and simultaneously press the 'Sleep/Wake' button on the right-hand edge near the camera lens. This will take a screen shot, which will then appear in your photo gallery.

Software
Software is a generic term for computer programs. On mobile devices such as iPads, apps are software, e.g. ArtRage is an app.

Stylus
A tool used for drawing, painting or for entering text on a touch screen. Many kinds of stylus are available to buy locally or on the Internet. It is a very personal choice which one you choose to use.

Tablet
A tablet is a generic term for a mobile computer with a touch screen display. There are several manufacturers of tablets, including Apple, Samsung, Microsoft, and Amazon.

Wi-Fi
Abbreviation for Wireless Fidelity. It is a local area wireless technology that allows a computer device to participate in a computer network. For example, if a friend brings her iPad to your house and wishes to use the Internet, she can connect via your Wi-Fi to the Internet if her own iPad is not equipped with its own built-in Wi-Fi.

Abstract Still Life by Angela Whitehead. The inspiration for this picture originated from Angela looking at a classical Old Master painting from the seventeenth century. The ArtRage app was used to make the picture. Each object in the picture was simplified into a geometric shape, but the basic colour and tonal structure remained the same as the original. She used several layers to make the picture, with some objects needing to have their own individual layers. The success of the picture required the objects to have very clean edges, so, after drawing the shapes with the Wax Crayon tool, all the edges were made more precise with the use of the Eraser. If this had been done on just one layer it would have disturbed the background.

Index